THIS JOURNAL BELONGS TO:

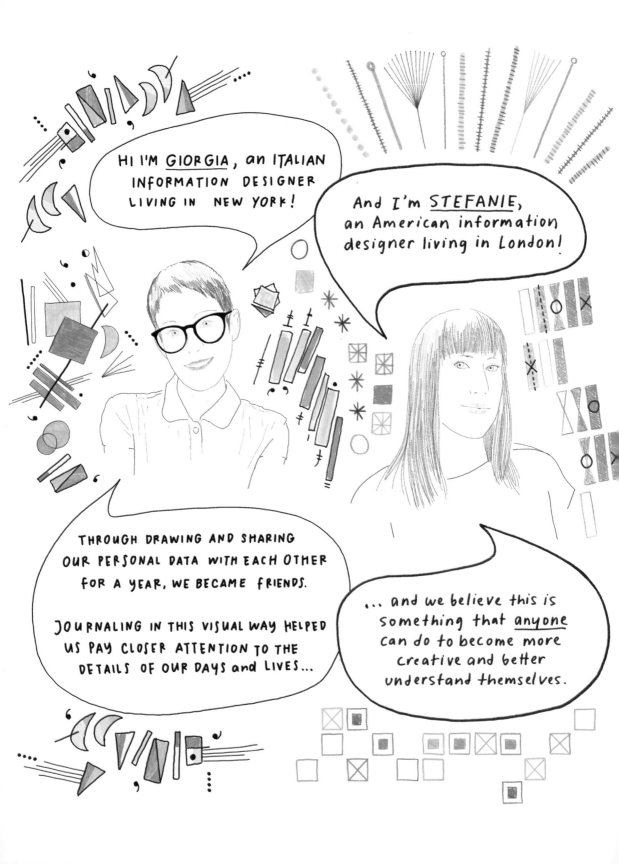

THIS DIARY IS FOR YOU, TO START YOUR JOURNEY TO THE WORLD OF PERSONAL DOCUMENTATION.

WE HOPE IT WILL INSPIRE YOU IN MANY WAYS:

- To see your world through a new lens, where everything and anything can be a creative starting point for play and expression;

- TO SLOW DOWN AND APPRECIATE THE SMALL DETAILS OF YOUR LIFE, AND TO MAKE CONNECTIONS WITH OTHER PEOPLE;

- To see data as a tool you can use for your daily life;

- TO DISCOVER THROUGH THE DATA·DRAWING PROCESS A PREVIOUSLY UNTAPPED WELL OF CREATIVITY.

HAPPY JOURNALING!

How Does This Journal Work?

THERE ARE THREE MAIN SECTIONS IN THE JOURNAL:

_LEARNING TO SEE

OVERCOME YOUR FEAR OF THE BLANK PAGE WHILE
LEARNING MORE ABOUT USING DATA AS A MATERIAL.

taking visual inspiration......... and building your set of tools

- OBSERVING, COLLECTING, DRAWING

IMMERSE YOURSELF IN THE WORLD OF DATA WITH
OUR GUIDED ACTIVITIES: OBSERVE, ACKNOWLEDGE,
COUNT, AND DRAW.

MY SMILES

DRAW!

- CRAFTING YOUR VISUAL LANGUAGE

OPEN-ENDED IDEAS FOR DRAWINGS USING YOUR OWN
DATA, WITH YOUR OWN RULES AND YOUR OWN STYLE.

Building YOUR own vocabulary
To use Data as a design Tool.

MY CITY

YOUR RULES DRAW!

THERE ARE ACTIVITIES OF **DIFFERENT LENGTHS** SO YOU CAN
EASILY FIT THEM IN YOUR LIFE:

- SINGLE-SITTING ACTIVITIES WHERE YOU COLLECT AND DRAW
 YOUR DATA IN ONE GO
- DAILY, WEEKLY, MONTHLY, AND CONTINUAL ACTIVITIES:
 DON'T BE INTIMIDATED BY THE LONGER ACTIVITIES: THE LONGER THE
 TIMEFRAME, THE SIMPLER THE COLLECTION AND DRAWING!

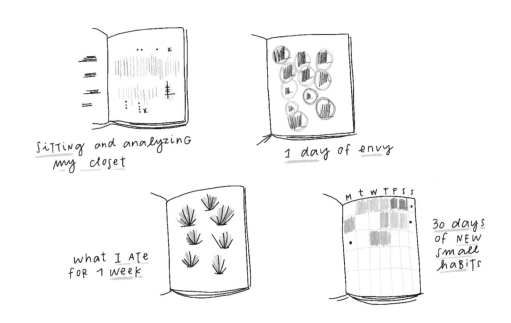

Sitting and analyzing
my closet

1 day of envy

what I ate
for 1 week

30 days
of NEW
small
habits

YOU CAN LOOK AT YOUR LIFE **FROM EVERY ANGLE** THROUGH:

- PERSONAL DOCUMENTARY ACTIVITIES IN WHICH YOU CAPTURE
 AND DRAW YOUR ACTIONS THROUGH EXPERIENCES OVER A
 CERTAIN LENGTH OF TIME;
- SURVEYS IN WHICH YOU TAKE STOCK OF DIFFERENT PARTS OF
 YOUR LIFE, RANGING FROM THE PHYSICAL (YOUR CLOSET) TO THE
 EMOTIONAL (YOUR PAST);
- CHALLENGES IN WHICH THROUGH TRACKING and DRAWING
 DIFFERENT BEHAVIORS YOU CHANGE YOUR BEHAVIOR.

THE ORDER YOU CHOOSE TO UNDERTAKE
THE ACTIVITIES IS UP TO YOU

INTRODUCTION

LEARNING TO SEE

BUILD YOUR OWN VISUAL VOCABULARY
WHAT CAN WE LEARN FROM VARIOUS FIELDS
TEST YOUR DRAWING MATERIALS
TRY SHOWING EMOTIONS THROUGH DRAWING SHAPES
DRAWING AS MEASURING
RHYTHMS OF MY BODY
DRAWING VARIATIONS OF BASIC SHAPES
FOLLOWING THE RULES (USING YOUR DATA)
DRAWING RULES + DATA = VARIABILITY!
COLOR PALETTE TESTING

OBSERVING, COLLECTING, DRAWING!

ONE SITTING

ONE DAY

FIVE DAYS

WHAT IS DATA?

Every plant, every person, and every interaction
we take part in can be mapped, counted,
and measured, and these measurements are
what we call data.

Once you know how to find these invisible
numbers, you begin to see these numbers
everywhere, in everything.

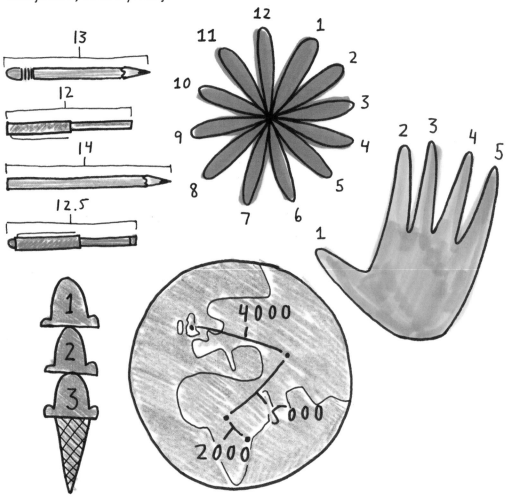

WHY DOES IT MATTER?

DATA COLLECTED FROM LIFE CAN BE A SNAPSHOT OF THE WORLD IN THE SAME WAY THAT A PICTURE CATCHES SMALL MOMENTS IN TIME, AND IT CAN BE USED TO DESCRIBE THE HIDDEN PATTERNS FOUND IN EVERY ASPECT OF LIFE, FROM OUR DIGITAL EXISTENCE TO THE NATURAL WORLD.

BY SEEING THE WORLD THROUGH THE LENS OF DATA, AND SKETCHING THE PATTERNS YOU DISCOVER IN THE DETAILS OF YOUR LIFE, YOU CAN ENCOURAGE YOURSELF TO NOTICE MORE CLOSELY THE LIFE UNFOLDING AROUND YOU, AND BECOME MORE IN-TUNE WITH YOUR WORLD AND YOURSELF IN THE PROCESS.

"... ALL OF THE TIMES YOU HELPED ME LAST WEEK..."

"... THE MOMENTS I FELT GRATEFUL TODAY..."

"... THE TRIPS I'VE BEEN ON...

→ ALONE

→ WITH FAMILY

→ WITH FRIENDS

→ OVERSEAS

"... MY SLEEPING PATTERNS FOR ONE WEEK..."

1 2 3 4 5 6 7 8 9 h

SLEEPING

AWAKE IN BED

PAINT, PAPER, CLAY... AND DATA!

For centuries, artists have used paper and pencils to sketch the life unfolding around them, but in the digital age, data has become a creative material like paint or paper, offering a new way of seeing and engaging with the world.

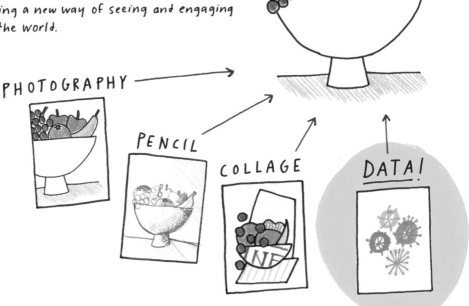

PHOTOGRAPHY

PENCIL

COLLAGE

DATA!

You can use your data as a starting point not only for drawings and discovery, but also in other creative projects, such as jewelry, gifts, textile patterns, sculptures, and more!

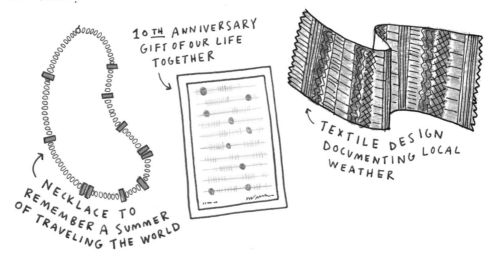

10TH ANNIVERSARY GIFT OF OUR LIFE TOGETHER

NECKLACE TO REMEMBER A SUMMER OF TRAVELING THE WORLD

TEXTILE DESIGN DOCUMENTING LOCAL WEATHER

FINDING FREEDOM IN CONSTRAINTS

AFRAID OF THE BLANK PAGE?
DRAWING WITH DATA WILL FUEL YOUR CREATIVITY.
AFTER YOU ESTABLISH A SET OF RULES, EVERY
SYMBOL, COLOR, PATTERN, OR LINE WILL BE
GUIDED BY SOMETHING YOU HAVE NOTICED,
COUNTED, AND CATEGORIZED.

`" IF _____ ,`
`THEN I WILL DRAW _____ "`

RULES FOR ORGANIZING MY DATA ON THE PAGE:

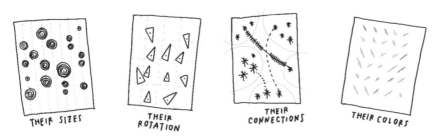

CHRONOLOGICALLY, DAYS and HOURS

ACCORDING TO 2 PARAMETERS

GROUPED BY TYPE

CHRONOLOGICALLY ONE AFTER ANOTHER

RULES FOR THE MAIN SHAPES FOR MY DATA:

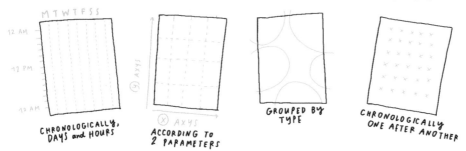

THEIR SIZES

THEIR ROTATION

THEIR CONNECTIONS

THEIR COLORS

ADD COLOR-BASED RULES FOR THEIR ATTRIBUTES:

COLLECTING AND DRAWING YOUR DATA

ALL OF THE ACTIVITIES FOLLOW THE SAME FORMAT:

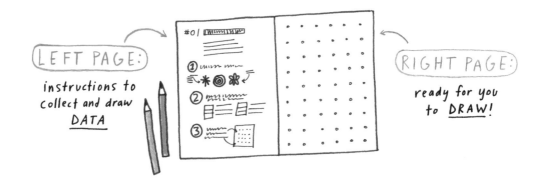

LEFT PAGE:
instructions to collect and draw **DATA**

RIGHT PAGE:
ready for you to **DRAW!**

THERE ARE LOTS OF DIFFERENT WAYS TO COLLECT YOUR DATA. USE WHATEVER WORKS FOR YOU!

PAPER

YOUR PHONE'S CALENDAR

NOTE-TAKING APPS

NOTEBOOKS

TAKING PHOTOS

HMM, WHICH PENS AND PENCILS TO USE?

PRE-COLORED LEGEND → USE THE SAME COLORS!

BLANK LEGEND → CHOOSE YOUR OWN COLORS!

READY TO SHARE YOUR DRAWING WITH THE WORLD?

#DEARDATA

#DEARDATA

JOIN OUR COMMUNITY AND COMPARE YOUR DATA WITH OTHERS!

#OBSERVECOLLECTDRAW

When sharing your drawings on social media, use the hashtags #DEARDATA and #OBSERVECOLLECTDRAW to link your work to the wider community of people documenting their lives through drawing!

#OBSERVECOLLECTDRAW

#DEARDATA

#DEARDATA

#DEARDATA

LEARNING TO SEE

OVERCOME YOUR FEAR OF THE BLANK
PAGE WHILE LEARNING MORE ABOUT
USING DATA AS A MATERIAL.

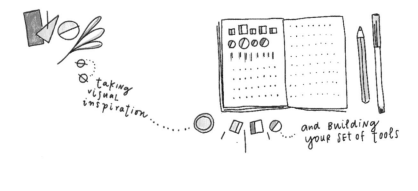

taking
visual
inspiration

and building
your set of tools

WHAT DO WE LIKE of WHAT WE SEE?
WHAT ELEMENTS, ASPECTS, AND FEATURES DO
WE APPRECIATE and WHY?

LEARNING TO SEE AND TO UNDERSTAND THE AESTHETIC
QUALITIES THAT ATTRACT US IS ESSENTIAL FOR
CREATORS OF ANY KIND.

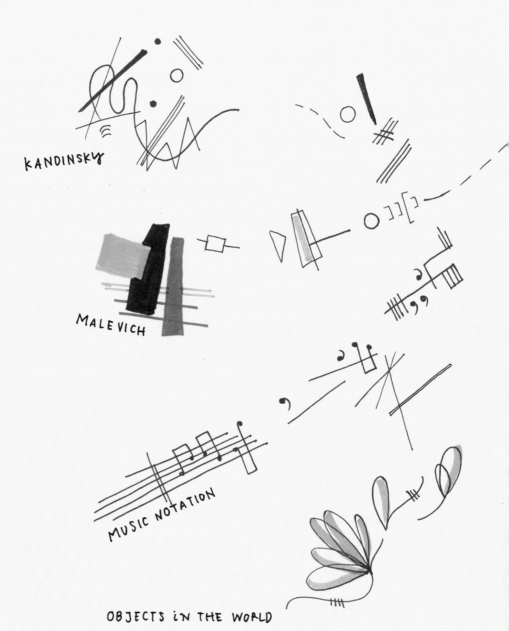

KANDINSKY

MALEVICH

MUSIC NOTATION

OBJECTS iN THE WORLD

TO LEARN TO DESIGN YOU HAVE TO LEARN HOW TO S👁️👁️

WITH TIME WE CAN LEARN TO NOTICE
AND RECALL THEM WHILE CREATING SOMETHING NEW.
THIS IS AN OPEN INVITATION TO THE ART OF
OBSERVATION.

BUILD YOUR OWN VISUAL VOCABULARY

DID YOU KNOW THAT EVERYTHING YOU SEE AND LIKE CAN BECOME DESIGN MATERIAL FOR YOUR DATA?

COLOR VARIATION

TO INDICATE GROUPS OR
CATEGORIES OF ELEMENTS

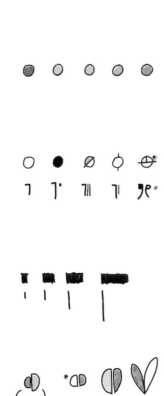

SYMBOL VARIATION

TO INDICATE DIFFERENT INSTANCES OF
THE SAME TYPE WITH TINY EXTRA SYMBOLS
TO REPRESENT A SPECIAL ENTRY

THICKNESS and LENGTH

TO VISUALIZE INCREASING DURATIONS
OR INTENSITIES

LEFT and RIGHT

FOR INDICATING A
BEFORE-AND-AFTER SITUATION

Before after

SHAPE VARIATION

LOOK AT HOW MANY VARIATIONS
THERE ARE FOR A LINE, A
SQUARE, A CIRCLE, OR A TRIANGLE!

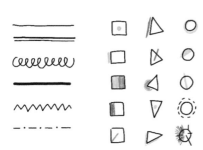

BY STARTING SIMPLE, YOU CAN
COMBINE ELEMENTS, ASSIGN LENGTHS ACCORDING
TO YOUR DATA RULES, AND CREATE BEAUTIFUL
AND COMPOUND SHAPES.

WHAT CAN WE LEARN FROM:

ABSTRACT ART

THOUGH APPARENTLY UNRELATED, ABSTRACT ART AND DATA VISUALIZATION ACTUALLY HAVE A LOT IN COMMON. WHILE CLEARLY PURSUING DIFFERENT GOALS, ABSTRACT ARTISTS AND DATA-VISUALIZATION DESIGNERS DRAW ON COMMON PERCEPTION PRINCIPLES AND APPLY THEM TO SIMPLE SHAPES AND A DEFINITE RANGE OF COLORS TO CREATE BASIC VISUAL COMPOSITIONS THAT PLEASE THE EYE AND DELIVER A MESSAGE.

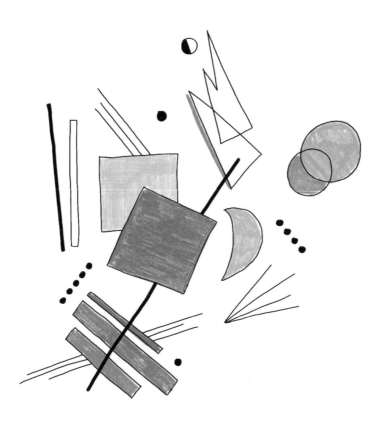

COMPOSITION : OVERLAP, ROTATION, AND JUXTAPOSITION OF SHAPES

COMPOSITION : THE ORIENTATION AND OVERLAP OF LINES

PERCEPTION : DISTINGUISHED COLOR PALETTES AND MATCHING COLORS

PERCEPTION : VARIATIONS IN SIZES

DETAILS : THE ELEGANT DETAILS ON TOP OF THE COMPOSITION THAT WE CAN USE TO REPRESENT PECULIARITIES IN OUR DATA

DETAILS : THE VISUAL HIERARCHIES (TOP TO BOTTOM, AND FOREGROUND AND BACKGROUND) CREATED BY THE INTERACTION OF VARIOUS ELEMENTS

WHAT CAN
WE LEARN FROM:
NATURE

TO EXPAND YOUR VISUAL VOCABULARY, YOU NEED TO CHANGE THE
WAY YOU LOOK AT THE WHOLE WORLD AROUND YOU, AND NOT ONLY
AT ART; STOP SEEING ONLY THE BIG PICTURE AND LOOK FOR DETAILS.
EVEN THE NATURAL ELEMENTS AROUND YOU ARE A GREAT SOURCE OF
INSPIRATION FOR SHAPES, PATTERNS, TEXTURES, AND OVERALL HARMONY!

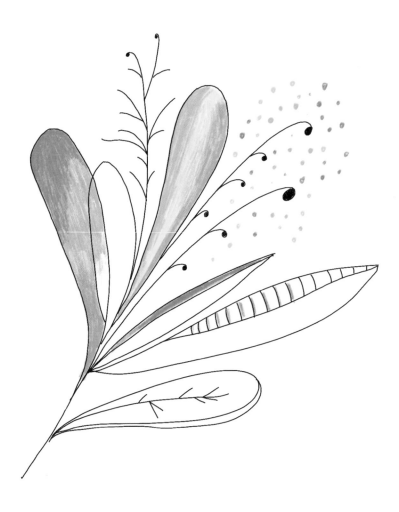

COLOR GRADIENTS

VARIATIONS IN THE SHAPES OF PETALS AND LEAVES

TINY ELEMENTS AND THEIR VARIATIONS

COMBINING COLORS AND PATTERNS

ADDITIONAL BACKGROUND COMPONENTS

WHAT CAN WE LEARN FROM:

ASTRONOMICAL DIAGRAMS

DIAGRAMMATIC REPRESENTATIONS CAN TEACH US A LOT AS WELL:
THEY ARE ALREADY INFORMATION LANGUAGES. ASTRONOMY
DIAGRAMS, FOR EXAMPLE, EXPLAIN DIFFICULT ASTRONOMICAL CONCEPTS
WITH CLEAR REPRESENTATIONS. A DATA-VISUALIZATION DESIGNER CAN
LEARN FROM ASTRONOMICAL DIAGRAMS HOW TO WORK WITH THE VARIATION
AND POSITION OF ELEMENTS AND THE CONNECTION BETWEEN THEM.

VARIATIONS OF SIMPLE ELEMENTS

CREATING SYSTEMS OF ELEMENTS

CONNECTING SYSTEMS OF ELEMENTS

VARIATIONS IN THE LOCATION AND OVERLAP OF ELEMENTS

THE DETAILS THAT VISUALLY MAKE THE DIFFERENCE

DOTS

PRESSING SOFTLY

PRESSING HARD

CROSSHATCHING

SCRIBBLE

TEST YOUR DRAWING MATERIALS!

Use these pages to experiment with new methods and techniques to find the right tools for each drawing.

THICK LINES

THIN LINES

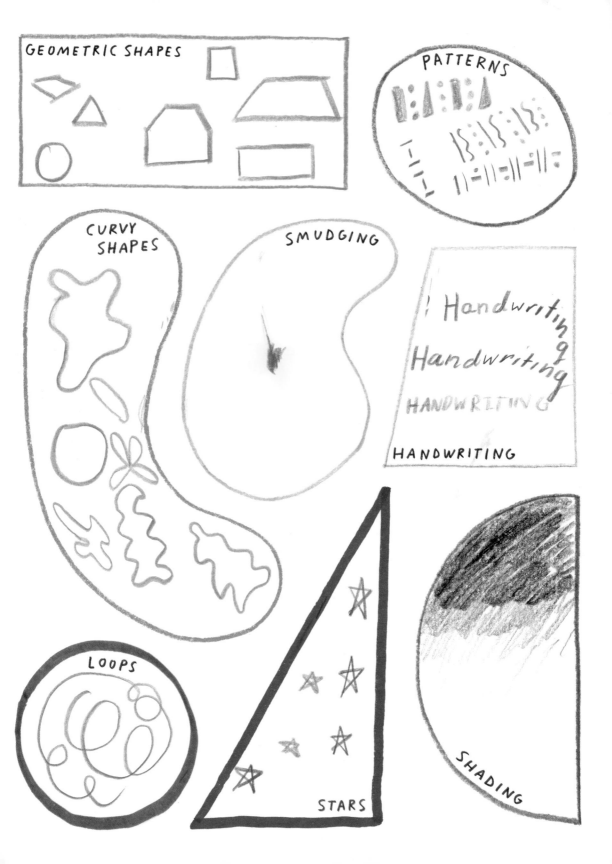

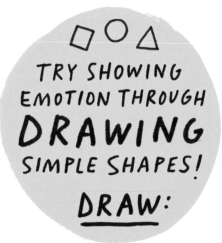

TRY SHOWING EMOTION THROUGH **DRAWING** SIMPLE SHAPES!

DRAW:

A CONFIDENT LINE

AN ANGRY LINE

AN *excited* CIRCLE

A *joyful* SQUARE

A *Shy* TRIANGLE

A *grieving* STAR

AN *undecided* LINE

A SURPRISED TRIANGLE

A PROUD SQUARE

AN *impatient* STAR

A FEARFUL CIRCLE

DRAWING AS MEASURING

Use your drawing as a way of measuring and capturing time. Set a timer for the times below and draw the following patterns until the time is up!

STARTING FROM THE DOT, DRAW AN EVER-GROWING SPIRAL FOR...

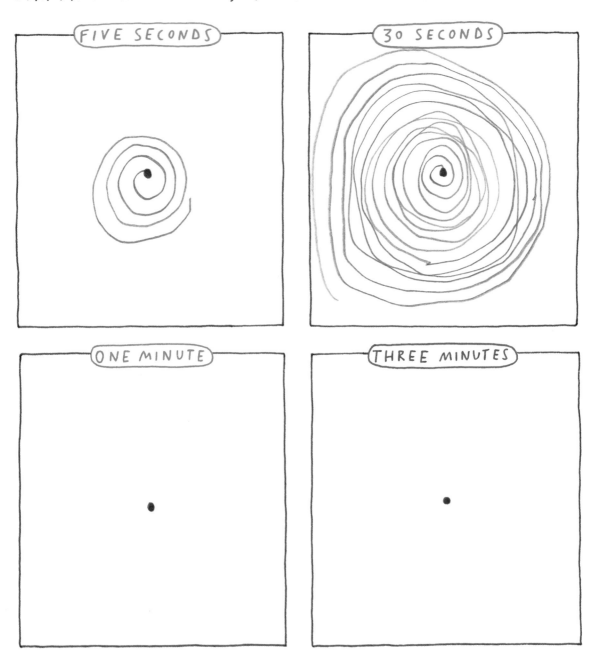

FIVE SECONDS

30 SECONDS

ONE MINUTE

THREE MINUTES

(that is ALL I can do because, if
I do more it won't end up well.)

DRAW AS MANY SMALL CIRCLES AS YOU CAN FOR...

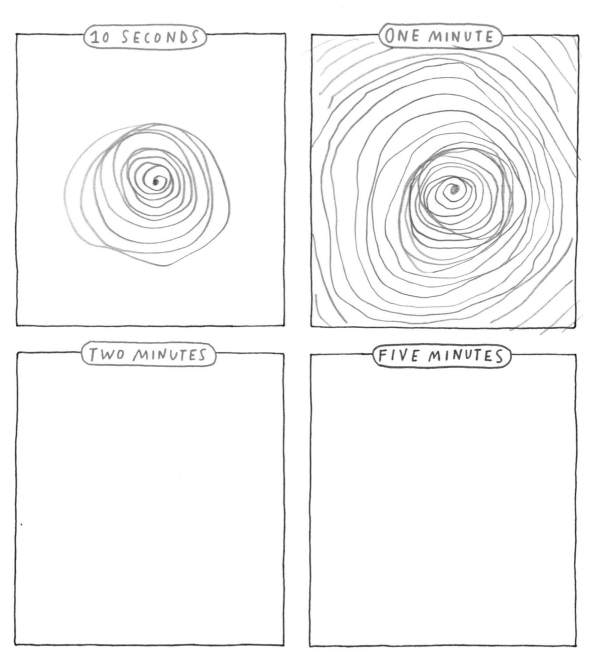

10 SECONDS

ONE MINUTE

TWO MINUTES

FIVE MINUTES

RHYTHMS OF MY BODY

If you find a quiet, calm place and tune into yourself, can you hear and feel the rhythms that come from within?

DRAW YOUR PULSE

Set a timer for THREE minutes.

Hold your (non-drawing) hand to your neck until you can feel your pulse.

Start the timer and for every beat, draw a / .

DRAW YOUR BREATH --------------------

Set a timer for THREE minutes.

Start the timer and for every full
inhale and exhale of breath, draw a ○.

DRAW EVERY BLINK OF AN EYE -------------

Set a timer for THREE minutes.

Start the timer and every time you
blink your eyes, draw a ∪.

HOW MANY VARIATIONS TO A RECTANGLE?

THIS IS A FIRST STEP TO BUILDING YOUR OWN VISUAL VOCABULARY: TAKE A VERY SIMPLE SHAPE, AND PLAY WITH ADDITIONS AND MODIFICATIONS.

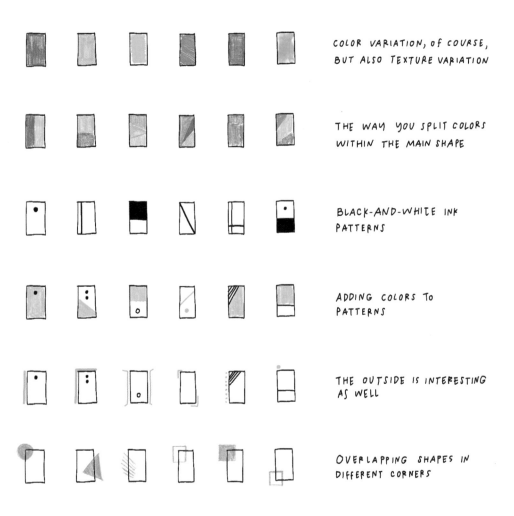

COLOR VARIATION, OF COURSE, BUT ALSO TEXTURE VARIATION

THE WAY YOU SPLIT COLORS WITHIN THE MAIN SHAPE

BLACK-AND-WHITE INK PATTERNS

ADDING COLORS TO PATTERNS

THE OUTSIDE IS INTERESTING AS WELL

OVERLAPPING SHAPES IN DIFFERENT CORNERS

COLOR COMBINATIONS, COLOR SPLITTING, and POSITIONS AND ROTATIONS OF THE ELEMENTS ARE EASY WAYS TO PRESENT VARIATIONS and DIFFERENCES IN YOUR DATA!

THIS IS A PAGE FOR YOU TO PLAY ON!

EXPERIMENT WITH DIFFERENT COMBINATIONS, OVERLAPS,
TEXTURES, and DRAWING MATERIALS, DRAWING as MANY
VARIATIONS ON THE MAIN SHAPES AS YOU CAN.

HOW MANY VARIATIONS TO A LINE? / | \ \

COMPLETE THESE TWO PAGES WITH DIFFERENT WAYS TO STYLE A
VERTICAL LINE. TEST ALTERNATIONS OF COLORS, MIX DIFFERENT STYLES,
AND EXPLORE! WHEN YOU ARE DRAWING YOUR DATA, ALL OF THESE
VARIATIONS WILL SERVE AS ELEMENTS FOR YOUR RULE-BASED DESIGN.

FOLLOWING THE RULES
(USING YOUR DATA)

Add your data in the blanks and then draw it following the drawing rules listed below!

DRAWING ONE

YOUR DATA

My age is _10_ .

DRAWING RULES

For every year, draw a .

DRAWING TWO

YOUR DATA (circle which applies)

Right now a little happy.
I feel... somewhat sad.
 very

DRAWING RULES

1. If you are sad, pick up a _BLUE_ pen, and if you are happy, pick up a _RED_ pen.

2. Draw a ❋, where _SIZE_ = how happy or sad you feel.

a little somewhat very

DRAWING THREE

YOUR DATA

There are __2__ people in my immediate family (parents, siblings, my partner, and children).

Of these family members,
__2__ live in the same house as me.
__0__ live elsewhere.

Of these family members,
__0__ are younger than me.
__2__ are older than me.

DRAWING RULES

1. Draw family members that live with you inside the circle, and draw members who live elsewhere outside the circle.

2. Draw a ▲ to represent family members who are <u>older</u> than you, or a ◯ to represent members who are <u>younger</u> than you.

DRAWING RULES
+ DATA =

Drawing with data requires setting up drawing rules that work well to represent any data, from a very small to a very large number.

Test how this works on the page by following the rules below to draw the outcomes for the remaining five numbers.

AS THE VALUE
INCREASES...

1 2 3 4 5 6 →

the dot
gets bigger

the line
gets thicker

the circle
gets darker

the square
grows redder

AS THE VALUE
INCREASES...

| 1 | 2 | 3 | 4 | 5 | 6 |

the shape has
more sides

the line gets
wobblier

the star has
more points

the square's
pattern becomes
more crosshatched

the flower grows
more petals

the face
becomes happier

COLOR PALETTE TESTING

On this page, test out possible
color palettes for your drawings!

CATEGORICAL COLOR PALETTES:

These colors are used to represent categories that
are very different from each other, so the colors you
choose must be different enough to easily tell apart!

cat dog bird fox mouse

SEQUENTIAL COLOR PALETTES:

A set of colors that progress step-by-step in ONE direction, used for increasing values and intensities.

DIVERGING COLOR PALETTES:

A set of colors that progress step-by-step in TWO directions, used to represent values and intensities that move in two directions from a central position.

OBSERVING, COLLECTING, DRAWING!

IMMERSE YOURSELF IN THE WORLD OF DATA WITH THESE GUIDED ACTIVITIES: OBSERVE, ACKNOWLEDGE, COUNT, AND DRAW FOLLOWING OUR SUGGESTIONS.

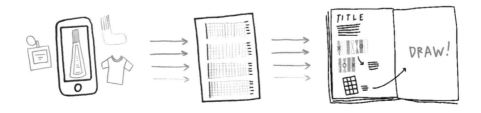

#01 MY BODY

How do you feel about your body, and how well/hard does your body work for you?

On the right, reflect on how you feel about every body part. Then, draw your feelings according to the rules below.

1. <u>SHAPE</u> and <u>COLOR</u> =
how you feel about each body part

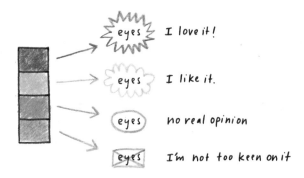

eyes — I love it!

eyes — I like it.

eyes — no real opinion

eyes — I'm not too keen on it

2. <u>YELLOW FILL</u> =
the five body parts you're most grateful for

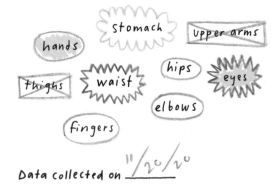

stomach
hands upper arms
thighs waist hips eyes
 elbows
fingers

Data collected on __11/20/20__

hair

eyes

forehead

eyelashes

ears

nose

chin

lips

back

chest

neck

shoulders

armpits

belly button

stomach

upper arms

hands

hips

waist

elbows

fingers

thighs

bum/bottom

lower arms

fingernails

calves

ankles

knees

feet

toes

heels

toenails

#02 BIRTHDAYS

HOW MANY OF YOUR FRIENDS' BIRTHDAYS CAN
YOU REMEMBER? HERE'S A VISUAL TEST.

1. FILL THE CALENDAR ON THE RIGHT-HAND PAGE,
COLORING THE TOP PART OF EACH DAY FOR ALL
YOUR FRIENDS WHOSE BIRTHDAYS YOU REMEMBER.

Jan 1

EVERY SQUARE ON THE RIGHT PAGE
CORRESPONDS TO ONE DAY.

Jan 1 2 3

FILL COLOR = TYPE OF PERSON

- CLOSE FRIEND
- CLOSE FRIEND FROM THE PAST
- ACQUAINTANCE
- COWORKER
- RELATIVE
- A CELEBRITY
- HISTORICAL FIGURE
- _____
- _____
- _____
- _____
- _____

S.P.

ADD TINY INITIALS, IF YOU WANT,
TO RECALL WHO THEY ARE LATER.

ADD A BLACK STROKE AROUND
YOUR BIRTHDAY.

ADD A DOT TO MARK
NATIONAL HOLIDAYS.

BE CREATIVE WHEN 2 OR MORE
PEOPLE HAVE A BIRTHDAY ON
THE SAME DAY.

2. WHEN YOU ARE DONE,
THINK OF ALL THE PEOPLE
WHOSE BIRTHDAYS YOU
SHOULD REMEMBER BUT
DON'T. GO ASK THEM,
AND FILL THE BOTTOM PART
OF EACH DAY WITH THEIR
BIRTHDAYS:

... HOPEFULLY FROM NOW ON
YOU WON'T FORGET THEM ANYMORE !

DATA COLLECTED ON_____

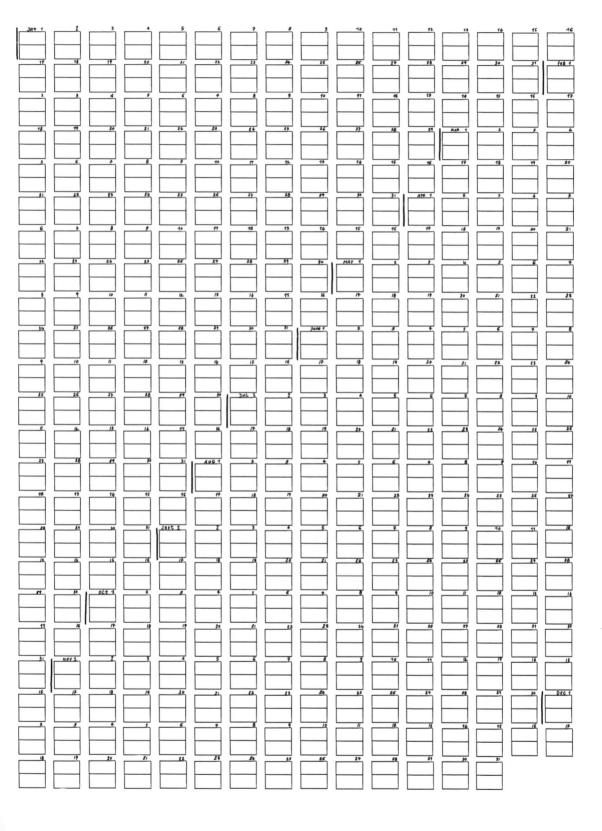

#03 HOW MUSIC MAKES ME FEEL

What emotions do your favorite songs inspire in you?

While listening, capture your emotions and moods for each part of the song, following the drawing rules below.

There's room for your top five favorites (a tough decision, we know!).

1. PRESS PLAY!

2. Every fifteen seconds draw a dot to indicate the intensity of emotion you feel in the moment.

3. When finished, join all of the dots together.

4. Color each time segment with the emotion you felt at that time.

sadness

happiness

5. Draw a symbol on top of a time segment to indicate:

your favorite part of the song

the point where you wanted to jump up and dance

ARTIST:

SONG:

emotional intensity →

0 1:00 2:00 3:00 4:00 5:00 6:00 7:00

ARTIST:

SONG:

0 1:00 2:00 3:00 4:00 5:00 6:00 7:00

ARTIST:

SONG:

0 1:00 2:00 3:00 4:00 5:00 6:00 7:00

ARTIST:

SONG:

0 1:00 2:00 3:00 4:00 5:00 6:00 7:00

ARTIST:

SONG:

0 1:00 2:00 3:00 4:00 5:00 6:00 7:00

ARTIST:

SONG:

#04 MY PHONE

The apps on your phone are a window
to your soul. What can you discover
about yourself?

Write down every app on your phone and
then categorize and draw your apps
following the instructions below.

1. Each app is represented by a circular SYMBOL

Apps are ordered on the grid from least to most used ⟶

2. COLOR = the app's genre

 photo and video

 social media

3. SHAPE = how often
you've used the app

 I've never used it

 only once or twice

 occasionally

 semi-regularly

 all the time

4. CIRCLE the apps that
you would be embarrassed
to tell others about.

5. Add DETAILS of your
most and least favorite
apps in the margins!

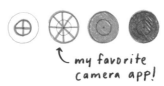

↖ my favorite
camera app!

Data collected on _____

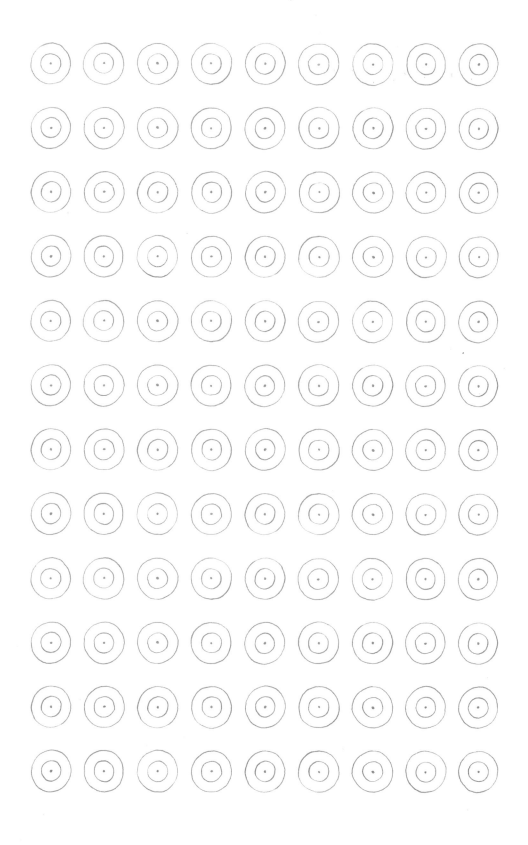

#05 MY FRIENDS

WHO ARE THE 15 PEOPLE you CONSIDER YOUR CLOSEST FRIENDS? WRITE THEM DOWN and START DRAWING YOUR RELATIONSHIPS!

1. POSITION YOUR FRIENDS ON THE GRID ACCORDING TO <u>WHEN YOU MET THEM</u>, AND WHEN YOU <u>LAST SAW EACH OTHER</u>.

DRAW A LITTLE DOT AND THEIR INITIALS TO BEGIN WITH.

CENTRAL DOT

MALE • FEMALE ◉

Grid columns: A B C D
Grid rows: 1 2 3 4 5

Grid contents:
- G (row 1)
- L, P, PB (row 2)
- SK, M, LB (row 3)
- SB, SC, J (row 4)
- F (row 5)

WHEN <u>did</u> you <u>MEET</u>?

WHEN WAS THE LAST TIME you <u>SAW</u> <u>each</u> <u>OTHER</u>?

1. TODAY / YESTERDAY
2. IN THE LAST WEEK
3. IN THE LAST MONTH
4. IN THE LAST YEAR
5. I HAVEN'T SEEN HER/HIM FOR MORE THAN A YEAR

A. WE GO WAY BACK
B. I MET HIM/HER DURING MY STUDIES
C. I MET HIM/HER IN THE LAST 2 YEARS
D. I MET HIM/HER IN THE LAST 6 MONTHS

2. THEN START DRAWING ELEMENTS AROUND THE CIRCLES TO DEPICT YOUR RELATIONSHIP:

COLORS ON TOP = THINGS WE TALK ABOUT
- ○ OUR RELATIONSHIP
- ○ OUR PAST
- ○ OUR JOBS
- ○ OUR DESIRES
- ○ _____
- ○ _____
- ○ _____
- ○ _____

1 element = 1 FRIEND

MAIN COLOR = TYPE OF FRIEND
- ○ confidant
- ○ old friend
- ○ _____
- ○ _____
- ○ _____
- ○ _____

ADD A LITTLE <u>LEAF</u> IF YOU WOULD CALL HIM/HER WHEN IN TROUBLE/NEED

ADD A <u>HALF CIRCLE</u> IF YOU'VE CRIED IN FRONT OF HIM/HER

ADD <u>3 DOTS</u> IF YOU ARE REGULARLY IN TOUCH VIA PHONE/ SOCIAL MEDIA, ETC.

3. ADD A FINAL TOUCH:

DRAW <u>CONNECTION LINES</u> FOR FRIENDS WHO KNOW EACH OTHER!

DATA COLLECTED ON _____

#06 MY BOOKS

What does your book collection reveal about you?

Take stock of your book collection (both digital and physical), making notes if needed. Next, organize and draw your books on the page.

1. Books are organized and drawn on the "bookshelf" in the order of your choice.

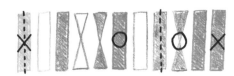

2. COLOR = the book's genre

comic

general fiction

general non-fiction

book for children or young adults

fantasy

science

realistic fiction

historical fiction

3. SHAPE = whether the book is physical or digital

 physical

 digital

4. FILL = the books you've actually read

5. BLACK DETAILING = extra information about the book

 was a gift

 one of my favorite books

 I hated this book!

6. ANNOTATE your drawing with additional information that's important to you!

my favorite childhood book!

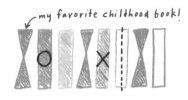

Data collected on ___8/20/2020___

#07 MY FAVORITE PAINTER!

GOOGLE YOUR FAVORITE ARTIST AND COMPOSE A DATA DRAWING ABOUT HIM OR HER. ON THE RIGHT-HAND PAGE, REPRESENT THE 15 IMAGES YOU FIND.

THIS IS APPROXIMATELY WHAT YOUR DRAWING SHOULD LOOK LIKE!

1. ON THE ARTIST

DRAW A DOTTED LINE ON THE LEFT SIDE IF THE ARTIST IS FROM YOUR HOME COUNTRY. (LEAVE IT BLANK IF NOT.)

DRAW A SOLID LINE ON THE BOTTOM SIDE IF THE ARTIST IS STILL ALIVE. (LEAVE BLANK IF NOT.)

DRAW A ● IF SHE IS A WOMAN
DRAW A ○ IF HE IS A MAN

2. ON THE PIECE

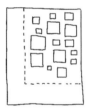

USE THE REMAINING SPACE IN THE PAGE AS YOUR <u>WALL</u>! DRAW A <u>SQUARE</u> FOR EACH OF THE 15 PIECES YOU FOUND. DRAW FROM TOP LEFT TO BOTTOM RIGHT.

SIZE THE SIZE OF THE SQUARE REPRESENTS THE SIZE OF THE PIECE.

XS S M L XL

COLOR

FILL EACH SQUARE WITH THE MAIN COLORS YOU CAN SPOT ON THE ARTWORK (MAXIMUM 4).

3. OTHER DETAILS

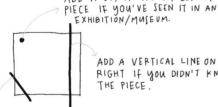

ADD A DOT ON THE TOP LEFT OF THE PIECE IF YOU'VE SEEN IT IN AN EXHIBITION/MUSEUM.

ADD A VERTICAL LINE ON THE RIGHT IF YOU DIDN'T KNOW THE PIECE.

ADD A DIAGONAL LINE ON THE BOTTOM-LEFT CORNER IF THE PIECE IS FIGURATIVE / REALISTIC.

STROKE

ADD A THICKER STROKE IF YOU REALLY LIKE THE PIECE.

DATA COLLECTED ON _____

#08 WHAT MY CAMERA SEES

What do you normally train your camera on?

Open the photo album on your phone and/or computer.

Choose a time period you want to survey (there's room for 160 photos), and add your dates to the drawing.

ONE WEEK?
ONE MONTH?
THREE MONTHS?

Each photo is represented by a <u>COLOR</u> and a <u>SYMBOL</u>.

1. <u>COLOR</u> = the location of the photo

home

work

social setting

outdoors

2. The <u>SYMBOL</u> = the type of photo you took

 selfie

 group photo

 landscape/cityscape

 interiors/still life

 note-taking or documentation
(receipts, photos of notes, references, etc.)

3. Connect multiple photos taken of the same thing.

4. Underline the photos actually worth keeping for the future!

5. Add additional notes in the margins near the photos.

↳ on holiday in greece

Photos were taken from _____ to _____

#09 MY CLOSET!

WHAT DOES YOUR CLOTHING COLLECTION LOOKS LIKE?
AND WHAT DOES IT SAY ABOUT YOU?
HOW MANY COLORS? GARMENTS OF THE SAME TYPE?
HOW OFTEN DO YOU WEAR THEM?
SHOULD YOU GET RID OF THEM?

IN A SINGLE SITTING, WALK INTO YOUR CLOSET WITH
THE EYES OF THE DATA COLLECTOR AND DRAW IT!

THIS PAGE →

WILL BE THE
VISUAL
REPRESENTATION
OF YOUR CLOSET →

1. COUNT THE CLOTHES
YOU CAN SEE (... UP TO YOU
IF YOU WANT TO OPEN DRAWERS!)
AND FILL THE PAGE WITH TALLY MARKS.

⌐ **I** = 1 GARMENT,
LEAVE SOME SPACE
BETWEEN EACH MARK.

BE CREATIVE WITH
MULTIPLE COLORS.

2. PROCEEDING IN ORDER,
START TO ADD THE MAIN
COLOR OF EACH GARMENT.

USE WHATEVER
DRAWING MATERIAL
YOU LIKE!

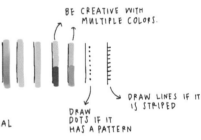

DRAW
DOTS IF IT
HAS A PATTERN

DRAW LINES IF IT
IS STRIPED

3. START ADDING DETAILS TO
EACH PIECE.
THIS IS OPTIONAL BUT FUN!

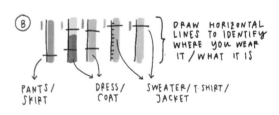

DRAW HORIZONTAL
LINES TO IDENTIFY
WHERE YOU WEAR
IT / WHAT IT IS

PANTS/
SKIRT

DRESS/
COAT

SWEATER/ T-SHIRT/
JACKET

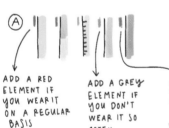

ADD A RED
ELEMENT IF
YOU WEAR IT
ON A REGULAR
BASIS

ADD A GREY
ELEMENT IF
YOU DON'T
WEAR IT SO
OFTEN

ADD A BLUE
ELEMENT IF
YOU DON'T
REMEMBER THE
LAST TIME YOU
PUT IT ON
... AHEM ...

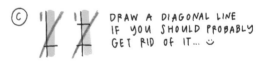

DRAW A DIAGONAL LINE
IF YOU SHOULD PROBABLY
GET RID OF IT... ☺

DATA COLLECTED ON _____

#10 MY PAST

What can your past tell you about yourself?

Look back over your life and reflect on the eras, moments, and people that made you who you are today, making notes if you need to (it's ok if your memory isn't too precise). The only rule: no regrets allowed!

1. Each BAR = five or ten years of your life (based on your age now).

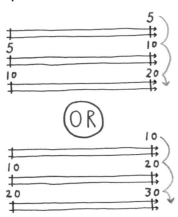

2. COLOR in the bar to show different life eras:

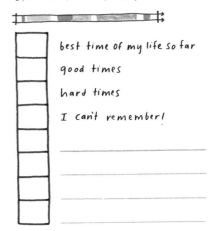

best time of my life so far

good times

hard times

I can't remember!

3. SYMBOLS = important moments and people, drawn on the timeline in the year you first met them.

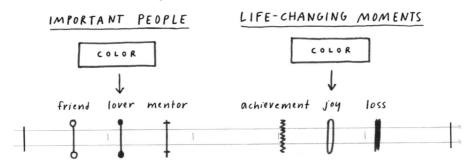

IMPORTANT PEOPLE

| COLOR |

friend lover mentor

LIFE-CHANGING MOMENTS

| COLOR |

achievement joy loss

4. ANNOTATE your drawings with additional details and memories.

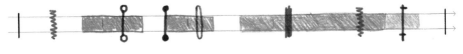

Data collected and drawn on _____

BIRTH

#11 MY TRAVELS

SIT DOWN AND RECALL ALL THE TRIPS (VACATIONS/HOLIDAYS)
YOU'VE TAKEN FOR LEISURE IN YOUR LIFE UP UNTIL NOW;
NOTE THE YEAR, THE PLACE, WHO YOU WERE WITH, AND
HOW YOU TRAVELED THERE, AND DRAW THIS DATA ON THE
ABSTRACT MAP ON THE RIGHT-HAND PAGE!

HOW DOES
THE <u>GRID</u> WORK?

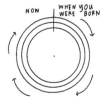

NOW WHEN YOU WERE BORN

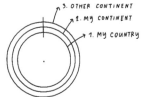

3. OTHER CONTINENT
2. MY CONTINENT
1. MY COUNTRY

IT'S A CIRCULAR <u>TIMELINE</u>,
FROM WHEN YOU WERE BORN
UP UNTIL NOW

THE 3 CIRCLES INDICATE <u>WHERE</u> YOU
TRAVELED: IN YOUR OWN COUNTRY, ON
YOUR CONTINENT, OR ON OTHER CONTINENTS

1. DIVIDE THE CIRCULAR GRID
ACCORDING TO YOUR CURRENT
AGE, SO THAT YOU CAN PLACE
YOUR TRIPS ONTO THE
CIRCULAR TIMELINE:

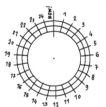

(IF YOU ARE <u>25</u> YEARS
OLD, YOUR CIRCLE WILL
BE DIVIDED INTO <u>25</u> PARTS)

2. MARK EACH VACATION WITH
A CROSS, ADD A COLORED LINE
TOWARDS THE EDGES OF THE
PAGE TO INDICATE WHO YOU
WERE WITH, AND A BLACK LINE
INDICATING HOW YOU GOT
THERE. DECIDE YOUR COLORS,
AND FOLLOW THE EXAMPLES
FOR THE TYPES OF LINES:

LINE COLOR
WHO WERE YOU WITH?

- ○ _family_
- ○ _friends_
- ○ _classmates_
- ○ _girlfriend/boyfriend_
- ○ _____
- ○ _____
- ○ _____
- ○ _____

LINE TYPE
HOW DID YOU GET THERE?

- —— CAR
- ---- TRAIN/BUS
- ····· PLANE
- ~~~ BOAT
- ⋀⋀⋀ OTHER

3. —ADD A <u>RED DOT</u> ● IF YOU REALLY
LOVED IT AND YOU WOULD RETURN
—CONNECT THE CROSSES THAT INDICATE
THE SAME PLACE, IN CASE YOU'VE BEEN
TO THE SAME PLACE TWICE, OR EVEN MORE.

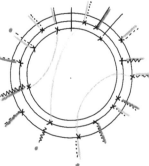

DATA COLLECTED ON _____

#12 THE SOUNDS AROUND ME

Can you capture the sounds around you that often slip away unnoticed?

Try drawing different settings to compare and contrast their different soundscapes.

(YOUR FAVORITE CAFÉ)
(LOCAL PARK) (LIVING ROOM)
(YOUR STREET)

1. Find a location, get comfortable, and set a timer for twenty minutes.

00:20

2. Start the timer and make note of every sound you hear.

train
children
truck passing
birdsong
photocopier

3. When the time is up, draw your sounds!

4. Each LINE = a sound

FIRST

Sounds are drawn in chronological order

LAST

Line COLOR = the general sound category

NATURAL SOUNDS	MECHANICAL SOUNDS	OTHER SOUNDS
COLOR	COLOR	COLOR

Line TEXTURE = the type of sound

WEATHER wind, rain, hurricane...	MEDIA music, tv, film, radio	CLANGS + CRASHES
ANIMALS birds, dogs, unicorns...	MACHINES lawn mower, coffee machines, etc.	RINGING + SIRENS
PEOPLE voices, footsteps, sneezes...	MOTOR VEHICLES bus, car, trunk...	HUMS + BUZZES
YOURSELF your breathing, movement, etc.	TRAINS + PLANES	SQUEAKS + SCREECHES

LOCATION:	LOCATION:	LOCATION:	LOCATION:	LOCATION:
DATE:	DATE:	DATE:	DATE:	DATE:
TIME:	TIME:	TIME:	TIME:	TIME:

you can
PAINT
a PORTRAIT
with DATA

HAVE YOU EVER THOUGHT YOU COULD
DRAW AN ABSTRACT PORTRAIT OF YOURSELF
AND YOUR DAYS THROUGH DATA, AND
LEARN MORE ABOUT YOURSELF?

EVEN IF YOU ARE NOT A DESIGNER
OR AN ARTIST, YOU CAN ENJOY THIS
MEDITATIVE ACTIVITY.

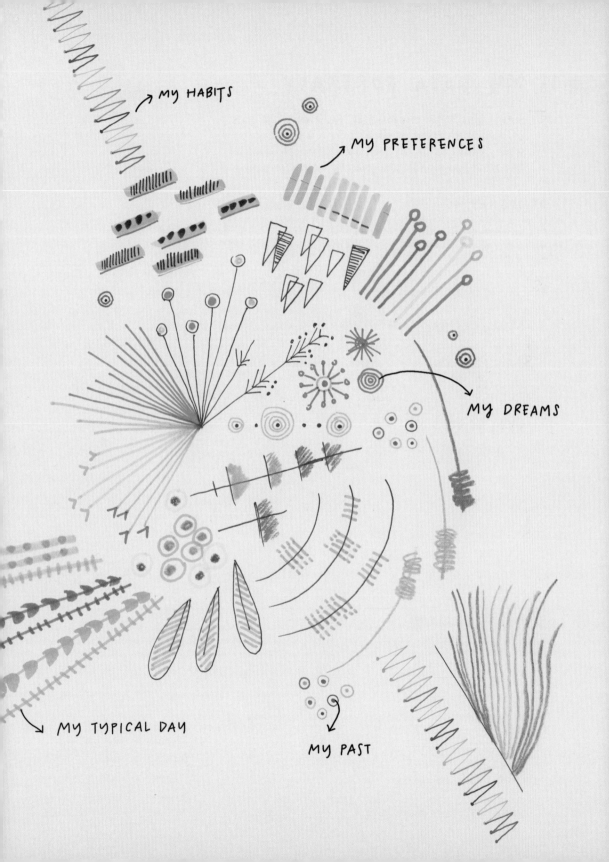

MY HABITS

MY PREFERENCES

MY DREAMS

MY TYPICAL DAY

MY PAST

#13 MY DATA PORTRAIT

HAVE YOU EVER THOUGHT OF DRAWING A PORTRAIT OF YOURSELF MADE OF DATA? GIVE IT A TRY. ASK YOUR FRIENDS TO DO THE SAME AND COMPARE! DRAW ON THE RIGHT-HAND PAGE ACCORDING TO THE FOLLOWING RULES:

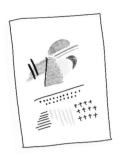

1. DEMOGRAPHIC

START WITH YOUR DEMOGRAPHIC: COMPOSE AN ABSTRACT ELEMENT DRAWING AND COLORING ACCORDING TO WHAT REPRESENTS YOU:

COLOR OF THE TRIANGLE:
- = I AM A FEMALE
- = I AM A MALE

COLOR OF THE LINES:
* TOP LINE = THE CONTINENT I LIVE IN
* COLORS OF THE OTHER LINES = CONTINENTS I HAVE BEEN TO

NORTH AMERICA
SOUTH AMERICA
EUROPE
ASIA
AFRICA
OCEANIA

(3) COLOR OF THE CIRCLE:
- I AM MARRIED
- I AM SINGLE
- I AM IN A RELATIONSHIP
- OTHER

(5) COLOR OF YOUR HAIR

(6) COLOR OF YOUR EYES

(4) LENGTH OF LINE, AND NUMBER OF DOTS: YOUR AGE (25 DOTS = 25 YEARS OLD)

2. PREFERENCES

FILL IN THE LOWER PART ACCORDING TO YOUR CHOICES.

COLOR OF LINES = DO YOU PREFER
- PEN
- PENCIL
- PIXEL

PATTERN FOR HORIZONTAL LINES: YOUR FAVORITE DAY IS:
- MONDAY
- TUESDAY
- WEDNESDAY
- THURSDAY
- FRIDAY
- SATURDAY
- SUNDAY

- ON THE COUCH WITH A MOVIE
- DINING OUT
- AT A CONCERT
- WORKING OUT
- MUSEUM
- SOMETHING UNPLANNED

COLOR OF VERTICAL LINES: YOUR FAVORITE NIGHT IS:

3. PERSONALITY

COMPLETE YOUR ABSTRACT PORTRAITS WITH ELEMENTS FROM YOUR PERSONALITY:

(2) DRAW A **BACKGROUND CIRCLE**, THE COLOR INDICATES IF THE GLASS IS
- HALF FULL
- HALF EMPTY
- DOESN'T HAVE ENOUGH ICE

(1) DRAW A SHAPE ON TOP OF THE LEFT SIDE, INDICATING IF YOU USUALLY ARE
- EARLY
- RIGHT ON TIME
- 15 MINS LATE
- ALWAYS RUNNING LATE

(3) FINISH WITH AN ARC, INDICATING IF YOU HAVE
- FEW CLOSE FRIENDS
- MANY CLOSE FRIENDS
- MANY ACQUAINTANCES

DATA COLLECTED ON ___11/20/20___

#14 MY DAILY ADORNMENT

How do you dress and adorn your body every day before facing the world?

Photograph every toiletry, beauty/grooming product, item of clothing, or accessory you put on as part of your routine.

Refer to your photo collection and draw according to the rules below.

Collect data on different days to see how what you wear changes in different situations!

WEDDING

WORKING FROM HOME

OUT SICK

DATE NIGHT

LINES = each item, drawn in chronological order and on the section of the body where it was placed/applied:

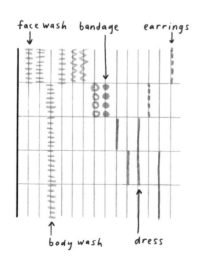

face wash bandage earrings

body wash dress

Each line's COLOR and PATTERN indicates the type of item you have put on or applied:

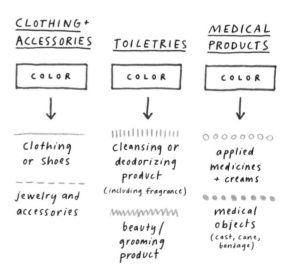

CLOTHING + ACCESSORIES

COLOR

↓

Clothing or shoes

- - - - - -

jewelry and accessories

TOILETRIES

COLOR

↓

cleansing or deodorizing product
(including fragrance)

beauty/grooming product

MEDICAL PRODUCTS

COLOR

↓

applied medicines + creams

medical objects
(cast, cane, bandage)

chronological order ⟶

DATE:

DRESSING FOR:

HEAD

HANDS/
WRISTS

TOP
HALF

BOTTOM
HALF

FEET/
ANKLES

DATE:

DRESSING FOR:

HEAD

HANDS/
WRISTS

TOP
HALF

BOTTOM
HALF

FEET/
ANKLES

DATE:

DRESSING FOR:

HEAD

HANDS/
WRISTS

TOP
HALF

BOTTOM
HALF

FEET/
ANKLES

DATE:

DRESSING FOR:

HEAD

HANDS/
WRISTS

TOP
HALF

BOTTOM
HALF

FEET/
ANKLES

#15 MY SWEARING

How and when do you swear in a day?

Pick a day when you are able to swear freely (like on the weekend), and make notes in your phone on each word you say following the rules and categories below.

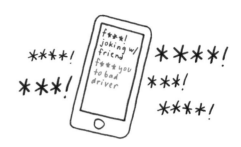

1. Divide your drawing by all the swear words you used.

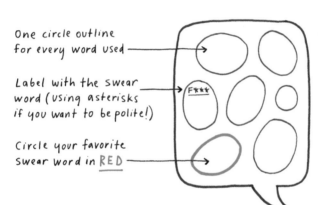

One circle outline for every word used —

Label with the swear word (using asterisks if you want to be polite!) → F***

Circle your favorite swear word in RED —

2. Each SYMBOL drawn in the circle = one instance of using that swear word

3. Symbol COLOR = who you were with when you swore

alone

friends

4. The symbol's SHAPE = the context of your swearing

 an insult to the person you were speaking to

 an insult towards someone/something you were talking ABOUT

 part of conversation or in jest, no insult meant

 exasperation

Data collected on _____

IT IS ONLY BY ADDING PERSONAL CONTEXT THAT YOU GET CLOSER TO REAL MEANING

AS WE BEGIN COLLECTING DATA
ABOUT OURSELVES, IT'S CRUCIAL
TO ADD CONTEXT AND DETAILS TO
OUR LOGS IN ORDER TO ENRICH THE
STORY AND MAKE IT PERSONAL, LEARN
MORE ABOUT OURSELVES, and BUILD
RICHER VISUAL NARRATIVES.

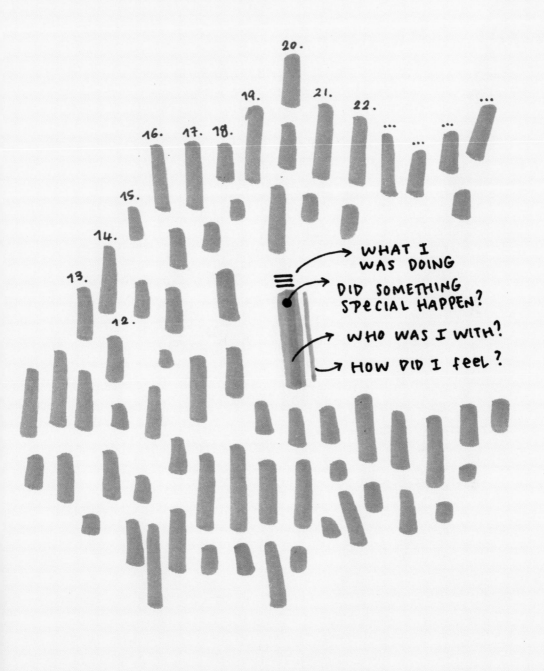

WHAT I WAS DOING

DID SOMETHING SPECIAL HAPPEN?

WHO WAS I WITH?

HOW DID I FEEL?

#16 MY TIME ALONE

TODAY FOR EVERY WAKING HOUR, RECORD THE TIME YOU'VE SPENT ON YOUR OWN AND THE TIME YOU WERE WITH OTHERS. WHAT DID YOU DO, AND HOW DID YOU FEEL?

THE GRID ON THE RIGHT-HAND PAGE WILL HELP YOU DRAW YOUR TIME AND ACTIVITIES: FROM THE TOP TO THE BOTTOM, THERE IS YOUR DAY UNFOLDING. FOR EVERY HOUR, YOUR TIME ALONE WILL BE ON THE RIGHT, YOUR TIME WITH OTHERS WILL BE ON THE LEFT.

MY TIME WITH OTHERS ← L | R → MY TIME ALONE

WHEN I WOKE UP

1 HOUR

WHEN I WENT TO BED

❋ YOUR DAY MIGHT END BEFORE THE END OF THE PAGE!

1. BREAK DOWN YOUR TIME IN 10-MINUTE SECTIONS (THEY NEED TO ADD UP TO 60!) AND MARK HOW YOU SPENT THE HOUR: USE COLORS TO INDICATE THE MAIN ACTIVITY.

60' 50' 40' 30' 20' 10' 10' 20' 30' 40' 50' 60'

= 30 MINS ALONE / 30 MINS WITH OTHERS

= 60 MINS ALONE

= 10 MINS ALONE / 50 MINS WITH OTHERS

MINUTES SPENT WITH OTHERS ← → MINUTES SPENT ALONE

= _Getting ready_
= _walking / commuting_
= _____
= _____
= _____
= _____
= _____
= _____

2. ADD TINY SYMBOLS ON TOP TO INDICATE HOW YOU WERE FEELING:

∿ = _calm_
•• = _productive_
– – = _annoyed_
//// = _____
|||| = _____
✳ ✳ = _____
ℓℓℓℓ = _____
⋁⋁⋁ = _____
ꓥꓥꓥ = _____

3. FOR THE TIME YOU SPENT WITH OTHERS: USE A COLOR TO INDICATE WHO YOU WERE WITH.

= _friends_
= _Coworkers_
= _____
= _____
= _____
= _____

DATA COLLECTED ON _____

#17 MY INBOX

HAVE YOU EVER PAID CLOSE ATTENTION TO EMAILS YOU RECEIVE AND READ EVERY DAY? HOW DO THEY MAKE YOU FEEL? WHAT ARE THEY ABOUT? FOR ONE DAY, EXAMINE THE EMAILS YOU GET FROM MORNING TO EVENING. IF YOU HAVE MULTIPLE ACCOUNTS THAT YOU REGULARLY CHECK, INCLUDE THEM ALL.

ORGANIZE YOUR EMAILS ON THE RIGHT-HAND PAGE:
- UNDERLINE VERTICALLY ACCORDING TO WHEN YOU GOT IT (MORNING, AFTERNOON, EVENING).
- HORIZONTALLY ACCORDING TO HOW IT MADE YOU FEEL.

DRAW YOUR OWN GRID, AND DRAW 1 DROP FOR EVERY EMAIL.

<u>1</u> EMAIL RECEIVED = 1 "DROP"

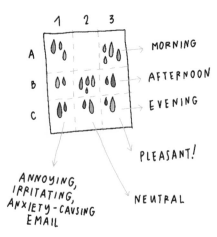

MORNING

AFTERNOON

EVENING

PLEASANT!

NEUTRAL

ANNOYING, IRRITATING, ANXIETY-CAUSING EMAIL

SIZE = EMAIL'S LENGTH

VERY LONG EMAIL

NORMAL EMAIL

SHORT ONE

THE <u>LENGTH</u> OF THE DROP REPRESENTS THE LENGTH OF THE BODY OF THE EMAIL.

OTHER DETAILS

ADD <u>1 DOT</u> FOR EVERY PERSON WHO WAS CC'D.

COLOR = THE TOPIC!

○ work request
○ work update
○ leisure
○ advertisement
○ friendly chat
○ _____
○ _____
○ _____
○ _____
○ _____
○ _____

COLOR SPLIT =

= <u>FULL COLOR</u> IF YOU WERE THE PRINCIPAL RECIPIENT

= HALF COLOR IF YOU WERE CC'D BUT NOT THE PRINCIPAL RECIPIENT

YOU CAN CONNECT EMAILS THAT WERE THREADS.

DATA COLLECTED ON _____

MOMENTS YOU DON'T NOTICE ARE AS TELLING AS THOSE YOU DO.

Looking closely at the reasons for "data voids" in your life is another way to learn more about yourself.

A WEEK OF DATA VOIDS

MONDAY — MEETING · THEATER

TUESDAY — FIGHT WITH HUSBAND

WEDNESDAY — WORK STRESS

THURSDAY — BOOZY LUNCH · CONCERT

FRIDAY — PARTY!

SATURDAY — HUNGOVER · LATE FOR TRAIN

SUNDAY — WEDDING

#18 DISTRACTIONS

What distracts you from getting things done?

Keep your journal near you, and as you are working, make note of the distractions.

Once all surveys have been completed, compare them to see what distracts you most!

1. Any color of pen or pencil can be used.

2. Before you begin, write down the date, start time, and the task you are working on.

 TASK: writing emails
 DATE: June 19 TIME: 2:30—

3. For every distraction draw a line from the center of the diagram to the distraction.

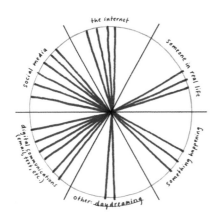

4. When you have finished collecting distractions, check the time and write it down!

 TASK: writing emails
 DATE: June 19 TIME: 2:30—3:30

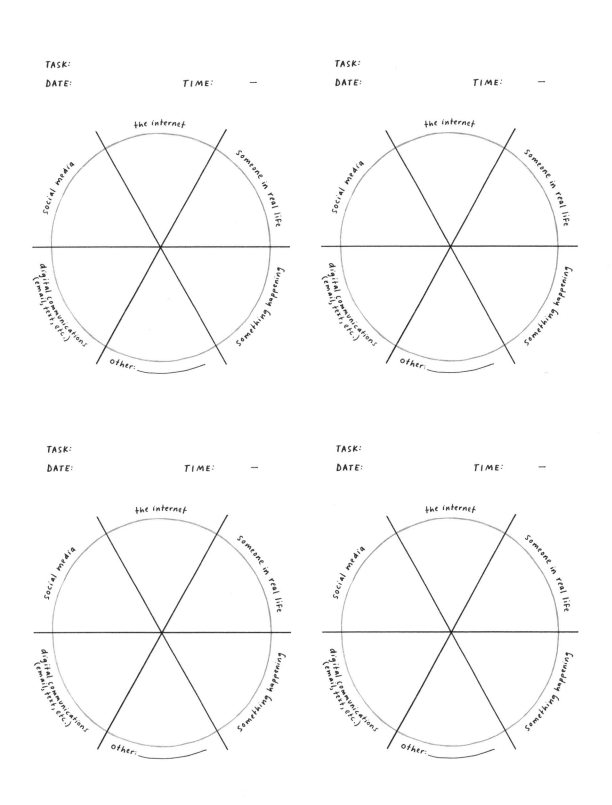

#19 MINDFULNESS

EVERY DAY FOR FIVE DAYS, SET ASIDE 20 MINUTES WHEN
YOU CAN SIT DOWN WITH YOUR EYES CLOSED, AND SEE WHERE
YOUR MIND GOES. SET AN ALARM CLOCK.

TRY TO FOLLOW YOUR BREATH AND BE IN THE MOMENT
WITHOUT WORRYING ABOUT WHAT BOTHERED YOU BEFORE OR
WHAT WILL HAPPEN NEXT.

LET IT BE A DRAWING MEDITATION: WITH YOUR COLORED
PENCIL IN YOUR HAND (A DIFFERENT COLOR EVERY DAY)
DRAW A CIRCLE ON THE RIGHT PAGE EVERY TIME YOU
CATCH YOUR MIND WANDERING, AND BRING YOURSELF BACK
TO YOUR BREATH AND TO THE PRESENT MOMENT.

DON'T WORRY
ABOUT WHERE
YOU ARE
DRAWING!

COLORS:

○ DAY 1
○ DAY 2
○ DAY 3
○ DAY 4
○ DAY 5

AT THE END OF THE SITTING, TRY TO REMEMBER THE MAIN
SOURCES OF DISTRACTIONS, AND WITH YOUR EYES OPEN,
SCATTER THEM ON THE PAGE, USING THE SAME COLOR:

FIND SPACE
FOR YOUR
DISTRACTIONS

⌐ MUNDANE TASKS I NEED TO TAKE CARE OF

| WORK-RELATED MATTERS

— THOUGHTS ABOUT THE PAST

╱ ANXIETIES ABOUT THE FUTURE

╲ _____

+ _____

ᴟ _____

DATA COLLECTED ON _____

#20 ENVY

WHAT DO YOU FEEL ENVIOUS ABOUT?
WHAT DOES IT TEACH YOU ABOUT YOURSELF?
FOR FIVE DAYS, ACKNOWLEDGE AND RECOGNIZE
ALL THE MOMENTS YOU FELT JEALOUS, AND
SCRIBBLE THEM ON THE RIGHT-HAND PAGE.

THIS IS ONE INSTANCE
OF <u>ENVY</u>

LINE COLOR =
WHO

a friend

a celebrity

CIRCLE COLOR =
WHAT ABOUT

◯ a person's life

◯ a person's appearance

◯

◯

◯

◯

SCRIBBLE SIZE =
BIGGER = MORE INTENSE

THE LONGER THE TAIL =
THE MORE PERSISTENT
THE FEELING

GIVE
YOURSELF
THE FREEDOM
TO FILL THE PAGE.
<u>NO RULES!</u>

LET IT BE
LIBERATING!

DATA COLLECTED ON _____

#21 COMPLAINTS

WHAT DO YOU NORMALLY COMPLAIN ABOUT? ARE YOU AWARE OF
YOUR COMPLAINTS? WHAT DO THEY TELL YOU ABOUT YOURSELF?
FOR <u>FIVE DAYS</u> NOTE YOUR COMPLAINTS, IDENTIFY
THE MOST COMMON SOURCES, AND COMPOSE YOUR MUSICAL
COMPLAINT SCORE ON THE RIGHT-HAND PAGE.

DEFINE YOUR OWN CATEGORIES
(EXAMPLES: TECHNOLOGY, A PERSON'S
BEHAVIOR, THE WEATHER, A PROJECT...)

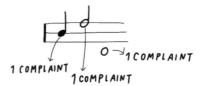

DRAW ONE "NOTE" FOR EVERY COMPLAINT.
DRAW IT ON THE LINE THAT CORRESPONDS TO
ITS TYPE: WHAT WAS THE COMPLAINT ABOUT?

1. POSITION:

POSITION YOUR NOTES ON THE GRID
ACCORDING TO HOW MUCH THE
COMPLAINT WAS NECESSARY:

- **D** THERE WAS A REAL NEED TO COMPLAIN!
- **C** IT WAS OKAY TO COMPLAIN
- **B** IT WAS NOT OKAY TO COMPLAIN :(
- **A** I AM BITING MY TONGUE NOW

2. TYPE of COMPLAINT

COLOR IN YOUR NOTE ACCORDING
TO WHO YOU SAID IT TO:

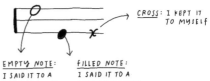

CROSS: I KEPT IT
TO MYSELF

EMPTY NOTE:
I SAID IT TO A
PERSON I DON'T
KNOW WELL

FILLED NOTE:
I SAID IT TO A
PERSON I KNOW
VERY WELL

3. ATTRIBUTES

ADD VERTICAL LINES TO YOUR NOTES
IF THE COMPLAINTS WERE IN REAL LIFE,
AND LEAVE THEM AS THEY ARE IF YOU
WROTE IT OR TEXTED IT.

ADD A RED DOT BEFORE THE NOTE
IF THE COMPLAINT IS SOMETHING YOU
FOUND YOURSELF SAYING OFTEN! ☺

DATA COLLECTED ON _____

#22 WHAT I EAT

Use your phone's camera to take a photo of everything you eat or drink for one week (including water).

Refer to these photos at the end of the week (or end of each day) when drawing, according to the rules below.

1. <u>LINES</u> = each item of food and drink

Lines are drawn in the time period when they were eaten

breakfast · lunch · dinner · other

ONE DAY OF MEALS

2. Line <u>LENGTH</u> = represents how nutritious the food is (Be honest!)

1 Nutritious and healthy

2 Healthy in moderation

3 OK, OK...this is junk food!

4 A very decadent indulgence!

3. Line <u>COLOR</u> and <u>TEXTURE</u> = the type of food consumed

FOOD
- Savory food
- Sweet food

DRINK
- Soft drink (including water)
- with caffeine
- with alcohol

4. <u>DOT</u> at the end of the line = highly processed food with a long list of ingredients

Data collected from _____ to _____

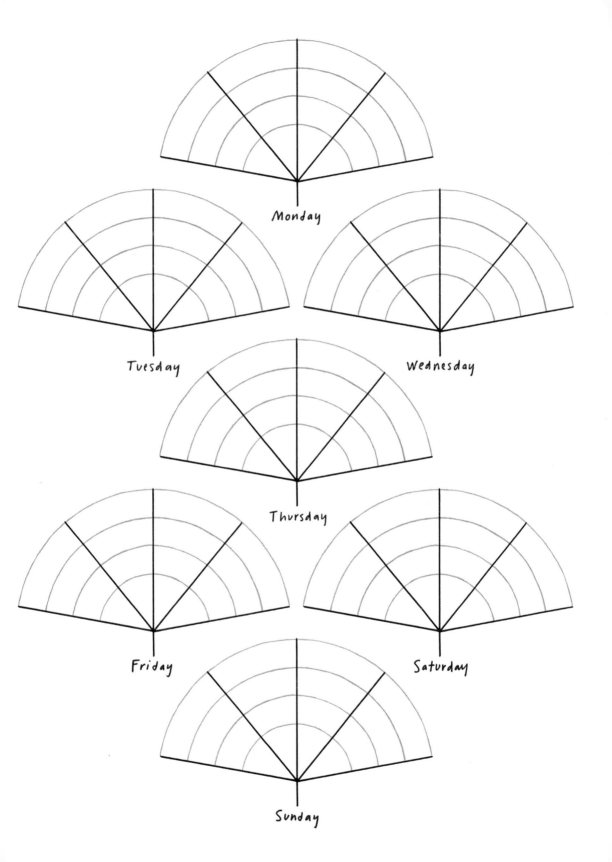

Monday

Tuesday

Wednesday

Thursday

Friday

Saturday

Sunday

#23 THINGS I BUY

What do your purchasing habits look like?

Save (or take photos of) all of your receipts, and draw a week (Monday–Sunday) of your purchases to discover what you spend your hard-earned cash on.

1. Each <u>LINE</u> = a single purchase

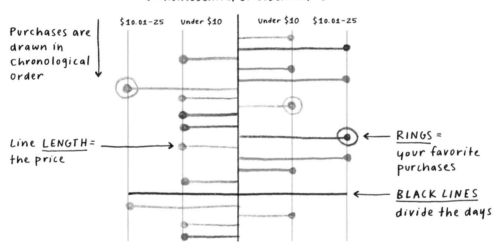

Line <u>DIRECTION</u> = whether the purchase was
← nonessential or essential →

$10.01-25 Under $10 Under $10 $10.01-25

Purchases are drawn in chronological order

Line <u>LENGTH</u> = the price

RINGS = your favorite purchases

BLACK LINES divide the days

2. Line <u>COLOR</u> = the type of purchase

transport	personal appearance (clothing, toiletries, hair appointments, etc.)
leisure and entertainment	eating out
hedonism and vices (alcohol, cigarettes, caffeine, etc.)	shopping for other people (gifts, children, etc.)
groceries and consumables	other

Spending tracked from _____ to _____

Currency: _____

←— NONESSENTIAL PURCHASES ($) ESSENTIAL PURCHASES ($) —→

over 100	50.01–100	25.01–50	10.01–25	Under 10	Under 10	10.01–25	25.01–50	50.01–100	over 100

over 100	50.01–100	25.01–50	10.01–25	Under 10	Under 10	10.01–25	25.01–50	50.01–100	over 100

←— NONESSENTIAL PURCHASES ($) ESSENTIAL PURCHASES ($) —→

#24 EMOTIONS

DO YOU USUALLY PAY CLOSE ATTENTION TO YOUR
FEELINGS? FOR ONE WEEK, FOR EVERY WAKING HOUR,
STOP, ACKNOWLEDGE, AND DRAW YOUR PRIMARY EMOTION.

FILL THE GRID ON THE RIGHT-HAND PAGE:
EVERY RECTANGLE CORRESPONDS TO ONE HOUR;
COLORS AND SYMBOLS INDICATE YOUR
PRIMARY EMOTION.

GRID ORGANIZATION:

VERTICAL:
THE 7 DAYS OF THE WEEK

HORIZONTAL:
WAKING HOURS
(START EVERY MORNING ON THE
FIRST RECTANGLE, NO MATTER
WHAT TIME IS IT)

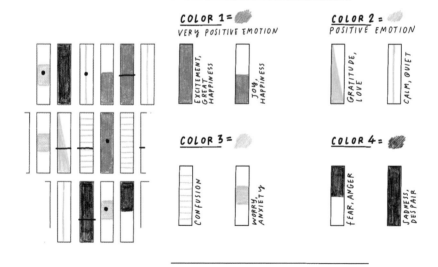

COLOR 1 =
VERY POSITIVE EMOTION

EXCITEMENT, GREAT HAPPINESS

JOY, HAPPINESS

COLOR 2 =
POSITIVE EMOTION

GRATITUDE, LOVE

CALM, QUIET

COLOR 3 =

CONFUSION

WORRY, ANXIETY

COLOR 4 =

FEAR, ANGER

SADNESS, DESPAIR

ADDITIONS:

ADD A LINE ON
TOP OF THE COLOR
IF DRAWING IT
MADE YOU REFLECT.

ADD A DOT ON TOP OF
THE COLOR IF SOMETHING
SPECIFIC HAPPENED TO
CAUSE YOUR FEELING.

DATA COLLECTED ON＿＿＿＿＿＿＿＿＿

#25 MY WORRIES

What do you worry about, and is this worrying often unnecessary?

For one week, from <u>MONDAY</u> to <u>FRIDAY</u>, whenever you worry, make a note on your phone. Once it's logged, do your best to stop worrying. (Distraction can help!)

Every evening (or the following morning), draw your worries, following the rules below.

1. Each <u>SYMBOL</u>= one worry

2. <u>COLOR</u>= what you're worrying about

myself

work/study

family

friends/social issues

my partner

world issues

3. The symbol's <u>PATTERN</u>= your reflective assessment of the worry

4. Starting at the bottom, draw worries on the side of the scale as below:

It's not likely/realistic this worry will happen ————

This worry is out of my control ————

This worry is in my control but is <u>NOT</u> my responsibility ————

This worry is in my control and I <u>CAN</u> do something about it! ————

WORRIES IN MY CONTROL

ALL OTHER WORRIES

Data collected from _____ to _____

WORRIES IN MY CONTROL ALL OTHER WORRIES

#26 BEING MORE KIND

THIS IS A WEEKLY ACTIVITY. EVERY DAY YOU
WANT TO PERFORM AT LEAST <u>SIX</u> ACTS OF KINDNESS.
FILL EACH ONE OF THE RECTANGLES, AND GET TO
SIX EVERY DAY.

THE COLOR OF THE DOT WILL REPRESENT WHO YOU'VE
BEEN KIND TO, THE FILLED COLOR FOR THE BOTTOM
HALF WILL INDICATE THE TYPE OF KIND ACT, AND
THE PATTERN ON THE UPPER PART WILL SYMBOLIZE
YOUR FEELINGS AFTERWARDS.

ADD A BLACK
LINE IF YOU
WOULD DO IT AGAIN.

PATTERN =
HOW DID YOU
FEEL AFTER?

DOT COLOR =
WHO WERE
YOU KIND TO?

FILL COLOR =
WHAT WAS THE
KIND ACT?

MON →

TUE →

WED →

THU →

FRI →

SAT →

SUN →

DATA COLLECTED ON_____

#27 FEELING CONFIDENT

For a week, whenever you feel confident, list it to the right (to refer to in times of doubt). At the end of the week, draw these moments to See where you draw most of your confidence from.

1. Each SYMBOL = a moment of confidence

 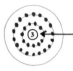

drawn around the number that corresponds with the list!

2. COLOR = the thing that gave you confidence

something I achieved

my personal style

a compliment I received

3. SHAPE = who you were with at the time

 just on my own

 my friends

 my partner

 my coworkers

 my family

 Strangers

4. SIZE = how confident the situation made you feel

a bit Confident Confident Super confident!

My moments of confidence

1. _____
2. _____
3. _____
4. _____
5. _____
6. _____
7. _____
8. _____
9. _____
10. _____
11. _____
12. _____
13. _____
14. _____
15. _____
16. _____
17. _____
18. _____
19. _____
20. _____
21. _____
22. _____
23. _____
24. _____
25. _____
26. _____
27. _____
28. _____
29. _____
30. _____
31. _____
32. _____
33. _____
34. _____
35. _____
36. _____
37. _____
38. _____
39. _____
40. _____

Data collected
from _____ to _____

#28 WEATHER MOOD

DO THE WEATHER AND COLOR OF THE SKY AFFECT YOUR MOOD?
LET'S TRY TO FIGURE IT OUT. FOR THE NEXT WEEK SET AN
ALARM CLOCK FOR EVERY WAKING HOUR FROM WHEN YOU
WAKE UP UNTIL THE SUN SETS, AND NOTE DETAILS ABOUT THE
SKY, YOUR PERCEIVED TEMPERATURE, AND YOUR FEELING.

YOUR FEELING

PERCEIVED
TEMPERATURE

THE SKY

1. HOW IS THE SKY?

FILL THE LOWER PART OF THE CIRCLE WITH THE
COLOR/PALETTE OF HOW YOU SEE THE SKY TODAY:

1 CIRCLE =
1 WAKING HOUR

 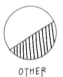

SNOWY RAINY SUNNY FOGGY CLOUDY OTHER

2. HOW HOT/COLD IS IT?

ADD 1, 2, OR 3 LINES IN THE CENTER FOR YOUR
PERCEIVED TEMPERATURE. ADD NOTHING IF YOU
THINK IT'S TOO COLD.

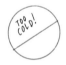 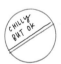 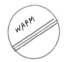 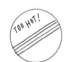

TOO COLD! CHILLY BUT OK WARM TOO HOT!

3. HOW ARE YOU FEELING?

THINK ABOUT HOW YOU HAVE GENERALLY FELT FOR
THE HOUR, AND TRY TO NOT CORRELATE IT WITH THE SKY.
YOU'LL SEE POTENTIAL CORRELATIONS AT THE END OF THE
WEEK FROM YOUR DRAWING!

COLOR ① COLOR ② COLOR ③ COLOR ④ COLOR ⑤

SAD ☹ GRUMPY OKAY, CALM JOYFUL, HAPPY EXCITED!

DATA COLLECTED ON _____

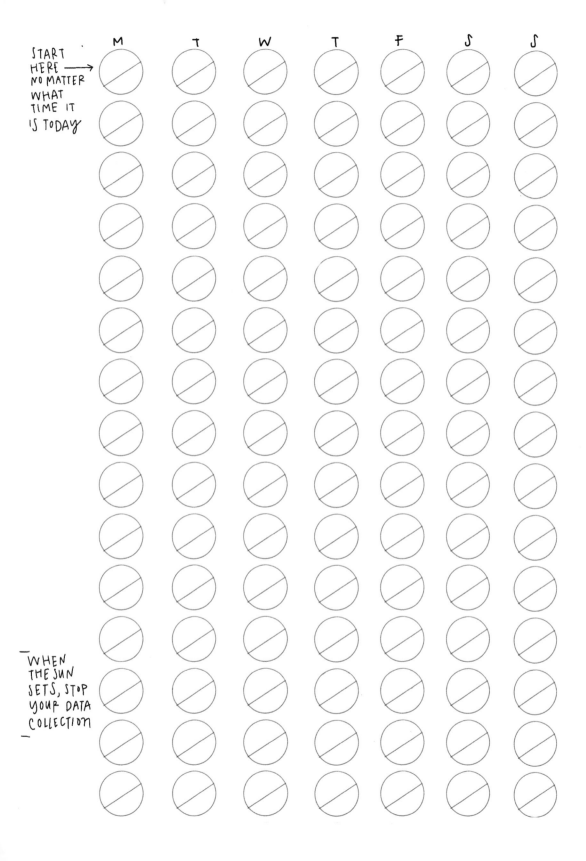

#29 BALANCING MY SCHEDULE

What does an honest depiction of your schedule look like? Is your schedule well balanced?

For an entire day, add to the calendar on your phone the start and end time for all your activities. When the day is complete, draw!

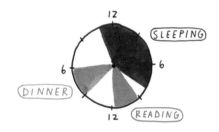

SLEEPING
DINNER
READING
12 / 6 / 6 / 12

1. Each **BAR** = an activity

HEIGHT = how long the activity took

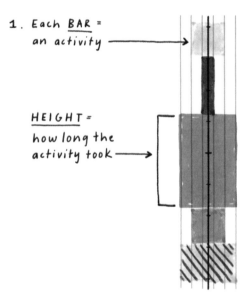

2. **COLOR** = the category of the activity you were doing

sleeping

mealtimes

3. The bar's **WIDTH** = how much you enjoyed the activity

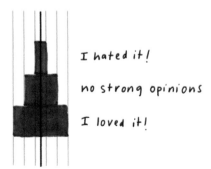

I hated it!

no strong opinions

I loved it!

4. A **PATTERN** drawn over the activity = activities you believe make life worth living!

Data collected from _____ to _____

MONDAY	TUESDAY	WEDNESDAY	THURSDAY	FRIDAY	SATURDAY	SUNDAY	

00:00

6:00

12:00
NOON

6:00

12:00
MIDNIGHT

#30 STARTING (AND KEEPING) A NEW HABIT

Can you make it through an entire month of starting a new habit?

Choose a habit you've always wanted to cultivate, and start your 30-day challenge. After each day, draw your success at making your habit stick.

There is space for two separate habits (or, um, a second try at the same habit if the first wasn't successful).

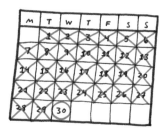

One path <u>SEGMENT</u>= daily habit-keeping results

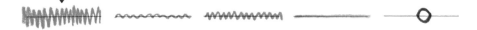

EVERY DAY

Did you keep your habit?

YES!

NO...

On this day, keeping my habit was

On this day, the things that threw me off track were

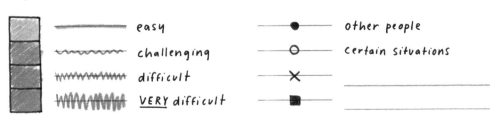

————	easy
∿∿∿∿∿	challenging
wwwwww	difficult
WWWWWW	VERY difficult

——●——	other people
——○——	certain situations
——✕——	_____
——■——	_____

THE HABIT I WANT TO KEEP:　　　　　FROM:　　　　　TO:

DAY 01

DAY 30

THE HABIT I WANT TO KEEP:　　　　　FROM:　　　　　TO:

DAY 01

DAY 30

#31 THANK you!

STARTING TODAY, NOTICE and COUNT ALL OF THE TIMES
YOU THANK SOMEONE. STARTING ON THE TOP LEFT OF
THE NEXT PAGE, DRAW A SPIRAL SCRIBBLE AROUND
THE DOTS EVERY TIME YOU SAY "THANK YOU." USE
COLORS TO IDENTIFY WHO IT WAS DIRECTED TO, AND
DRAW ITS SIZE ACCORDING TO HOW MUCH YOU
MEANT IT. IDEALLY, FINISH THE PAGE and WRITE DOWN
HOW MUCH TIME IT TOOK YOU TO FILL THE GRID.

 THIS IS ONE "THANK YOU!"
I SAID IN REAL LIFE.

COLOR OF THE SCRIBBLE =
WHO WAS IT FOR?

- a family member
- a coworker
- a stranger
-
-
-

SIZE OF THE SCRIBBLE =
HOW MUCH DID YOU MEAN IT?

= COURTESY THANK YOU

= I MEANT IT!

= I REALLY MEANT IT!

ADD DETAILS!

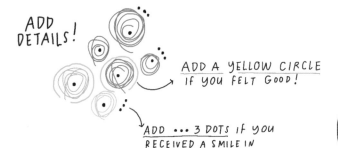

ADD A YELLOW CIRCLE
IF YOU FELT GOOD!

ADD ... 3 DOTS IF YOU
RECEIVED A SMILE IN
EXCHANGE.

* YOU CAN EVEN ADD IN MORE
DETAILS AND FIND YOUR OWN
WAY TO REPRESENT THEM, AND
REPORT IT IN THIS SPACE.

DATA COLLECTED FROM _____ TO _____

#32 OVERCOMING (AND OWNING) IMPERFECTION

Can being honest and recording your mistakes make you less fearful of imperfection?

Every time you make a small mistake, fail at something big, or have an embarrassing moment, instead of endlessly worrying about it, draw it and leave it behind.

Try to fill the page: the more you add, the more resilient and fearless you will become!

DIDN'T SAVE FINAL FILE!

TRIPPED AND FELL

MADE HUGE FAUX PAS

1. Each <u>SYMBOL</u>= one mistake

2. <u>COLOR</u>= how long until you can laugh about this mistake

I'm already laughing a little

A few days

A few weeks

A few months

It's going to take some time, but I'll get there!

3. Inner <u>SHAPE</u>= the type of mistake

 task based

 relationship based

 nothing but slapstick clumsiness (tripping, falling, etc.)

⊗ _____

⊗ _____

4. Outer <u>PATTERN</u>= who my mistake impacted the most

⊗ myself

 my friends

⊗ coworkers/collaborators

⊗ _____

⊗ _____

5. When you are finished drawing, cross out the symbol using <u>BLACK</u> and forgive yourself!

Data collected from _____ to _____

#33 BEAUTY

STARTING TODAY, NOTICE EVERYTHING THAT INSPIRES BEAUTY, AND INVESTIGATE YOUR IDEA OF "BEAUTIFUL."
IT CAN BE A PERSON'S APPEARANCE, A PERSON'S ATTITUDE, A FLOWER, THE SKY, OR A SONG YOU HEAR.
STOP FOR 30 SECONDS TO ACKNOWLEDGE THE SENSATION, AND DRAW IT!
FILL THE ENTIRE GRID ON THE RIGHT-HAND PAGE, AND INDICATE HOW LONG IT TOOK YOU TO FILL IT OUT.

DRAW YOUR INSTANCES OF BEAUTY. COMPOSE AN ABSTRACT FLOWER, FOLLOWING THE GRID ON THE RIGHT-HAND PAGE.

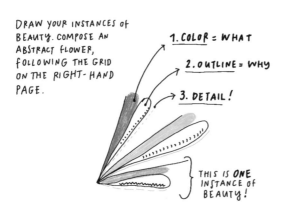

1. COLOR = WHAT

2. OUTLINE = WHY

3. DETAIL!

THIS IS **ONE** INSTANCE OF BEAUTY!

THE **LONGER** THE PETALS YOU DRAW, THE MORE BEAUTIFUL THE THING YOU ARE DESCRIBING

1. COLOR = WHAT

START BY DRAWING A COLORED PETAL ON THE RIGHT OF THE LINE IN THE GRID, INDICATING WHAT YOU FOUND BEAUTIFUL:

○ an object
○ a situation
○ a person's appearance
○ _____
○ _____
○ _____
○ _____
○ _____
○ _____
○ _____

2. OUTLINE = WHY

ADD AN OUTLINED PETAL, WITH A PATTERN THAT INDICATES WHY YOU THINK IT WAS BEAUTIFUL:

elegant

harmonious

made me feel calm

made me feel happy!

3. DETAIL!

ADD A LINE USING A DIFFERENT COLOR OF YOUR CHOICE, TO INDICATE IF:

IT'S SOMETHING FAMILIAR THAT I SEE EVERY DAY

IT'S SOMETHING NEW!

IT'S SOMETHING I KNOW IS THERE BUT ALWAYS OVERLOOK!

DATA COLLECTED FROM _____ TO _____

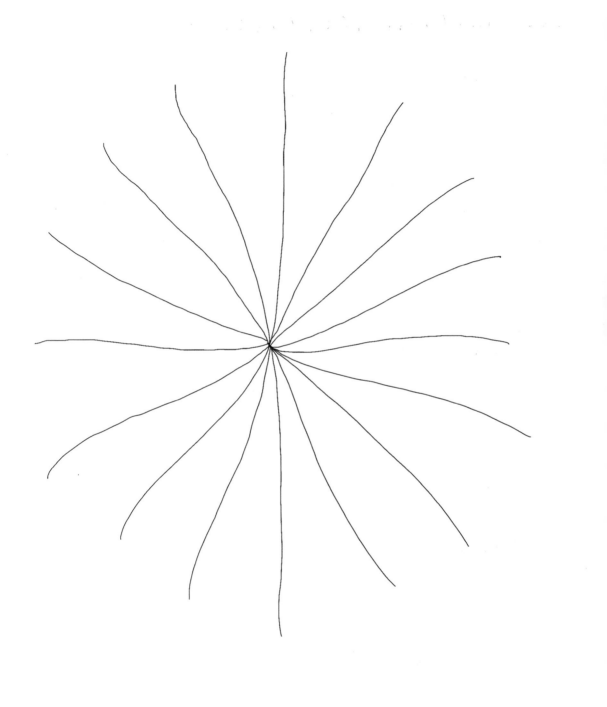

#34 SMILING AT STRANGERS ☺

STARTING TODAY, AND CONTINUING UNTIL YOU COMPLETE
THE RIGHT-HAND PAGE, SMILE AT AS MANY STRANGERS
AS YOU CAN! NOTE THEIR REACTION AND HOW YOU FELT AFTER.
THEN INDICATE HOW LONG IT TOOK YOU TO FILL THE PAGE.

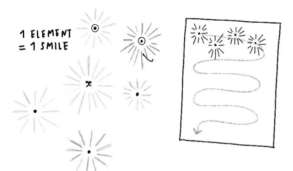

1 ELEMENT
= 1 SMILE

DRAW 1 DOT SURROUNDED BY A
RADIAL ELEMENT FOR EVERY SMILE
AT A STRANGER. FREELY FILL THE RIGHT
HAND PAGE, STARTING FROM THE TOP
LEFT AND PROCEEDING DOWNWARD.
YOUR GOAL IS TO FILL THE PAGE IN
AN ELEGANT WAY!

SIZE = HOW NICE WAS YOUR SMILE?

OKAY

VERY NICE!

SUPER!

DOT TYPE =

• I SMILED AT A WOMAN

◉ I SMILED AT A MAN

✖ I SMILED AT A CHILD

COLOR = THEIR REACTIONS:

THEY SMILED BACK

THEY DID NOT NOTICE

THEY PRETENDED THEY DIDN'T NOTICE

THEY SAID HI!

→ ADD A
CURVY LINE
IN A DIFFERENT
COLOR IF YOU
FELT BETTER
AFTER!

DRAW AN
EMPTY DOT
IF YOU COULD
HAVE SMILED BUT
DIDN'T.

DATA COLLECTED FROM _____ TO _____

#35 AN ODE TO THE ONE I LOVE

What situations inspire feelings of love for your loved one?

Whenever you feel love for your partner, list the moment to the right (for posterity and/or future love poems).

Draw these collected moments as they happen, and if you are feeling bold, show your drawing to your loved one when the page is filled!

1. Each <u>FLOWER</u>= one moment of love ⟶

 The number of <u>LEAVES</u> = the intensity of love ⟶ you felt

 1 2 3 4 5

2. <u>COLOR</u>= what your partner did

 Something he/she did for me

 Something he/she did for someone else

 how he/she looked

3. The flower's <u>SHAPE</u> = the moment's context

 extraordinary, grand romantic gesture like in a film _____

 ordinary, part of the every day life we lead together _____

 a new discovery, something that surprised me

 Data collected from _____ to _____

HOW DO I LOVE THEE?

Intensity of love (1-5)

1. _____
2. _____
3. _____
4. _____
5. _____
6. _____
7. _____
8. _____
9. _____
10. _____
11. _____
12. _____
13. _____
14. _____
15. _____
16. _____
17. _____
18. _____
19. _____
20. _____
21. _____
22. _____
23. _____
24. _____
25. _____
26. _____
27. _____
28. _____
29. _____
30. _____
31. _____
32. _____
33. _____
34. _____
35. _____
36. _____
37. _____
38. _____
39. _____
40. _____

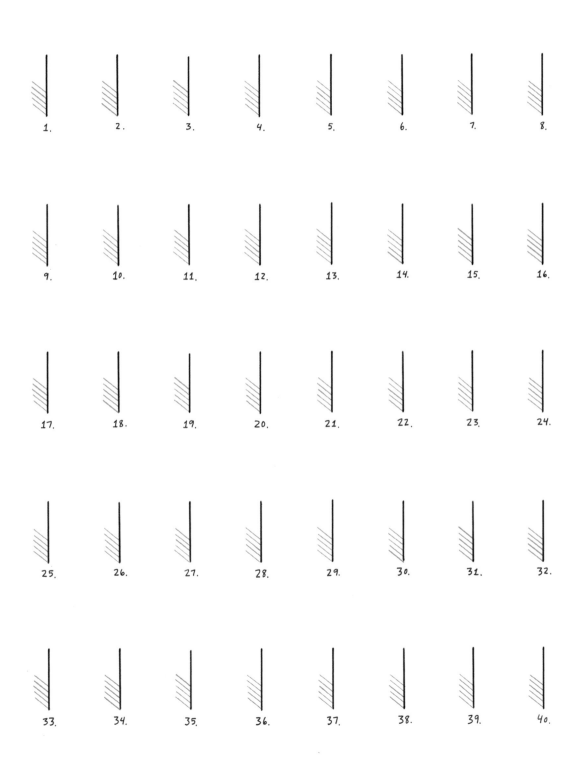

CRAFTING YOUR VISUAL LANGUAGE

OPEN-ENDED IDEAS FOR DRAWINGS USING
YOUR OWN DATA, IN YOUR OWN RULES,
WITH YOUR OWN STYLE.

YOUR RULES

DRAW!

SEE THE WORLD AS A DATA COLLECTOR

DATA PERMEATES OUR DAYS AND OUR LIVES,
IT'S JUST A MATTER OF LEARNING HOW TO
RECOGNIZE IT

..."MY INTERACTIONS..."

..."MY SMILES..."

..."MY SURROUNDINGS..."

..."MY COMPLAINTS..."

BEGIN WITH A QUESTION

BEGIN WITH A PRIMARY QUESTION:
WHAT DO YOU WANT TO KNOW AND EXPLORE?
THEN ENRICH THE DATA (AND GIVE THE DRAWINGS
DEPTH) BY ASKING ADDITIONAL SMALLER,
CONTEXTUAL QUESTIONS.

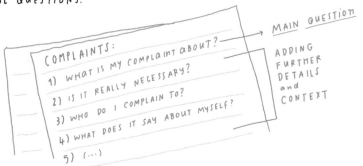

MAIN QUESTION

COMPLAINTS:
1) WHAT IS MY COMPLAINT ABOUT?
2) IS IT REALLY NECESSARY?
3) WHO DO I COMPLAIN TO?
4) WHAT DOES IT SAY ABOUT MYSELF?
5) (...)

ADDING
FURTHER
DETAILS
and
CONTEXT

GATHER THE DATA

Collect your data however you choose,
all the while being immediate, truthful,
and consistent in your data-gathering.

PAPER

YOUR PHONE'S
CALENDAR

NOTE-
TAKING
APPS

TAKING
PHOTOS

NOTEBOOKS

SPEND TIME WITH DATA

Before starting to visualize, always analyze
and spend time with your data, searching for
patterns and trying to understand it at
a deeper level.

__DATASET__

LEAVE THIS OUT

LOWEST
VALUES

HIGHEST
VALUES

INTERESTING!

ORGANIZE AND CATEGORIZE

Often it's good to simplify the data by
grouping it into larger categories based
on what will best communicate the story.

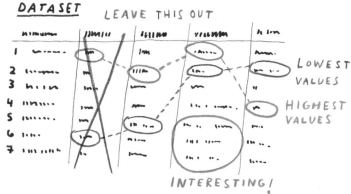

READING
CYCLING
GARDENING
COOKING
RUNNING

ANIMALS

FEMALE
FRIENDS

NATALIE
BLAISE SARAH
MIRIAM

DUCK
ELEPHANT
CAT SQUIRREL
DOG FOX

LEISURE
ACTIVITIES

FIND THE MAIN STORY

STARTING WITH PATTERNS DISCOVERED IN THE DATA, DECIDE WHAT THE MAIN STORY IS FOR THE DRAWING. FINDING THE DATA'S FOCUS HELPS DECIDE THE LAYOUT OF A DATA DRAWING.

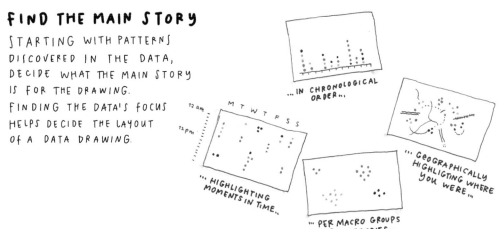

"...IN CHRONOLOGICAL ORDER..."

"...HIGHLIGHTING MOMENTS IN TIME..."

"...PER MACRO GROUPS OR CATEGORIES..."

"...GEOGRAPHICALLY HIGHLIGTING WHERE YOU WERE..."

GET VISUALLY INSPIRED

LOSE YOURSELF IN IMAGES, USING THE AESTHETIC QUALITIES OF THE FEATURES YOU ARE ATTRACTED TO AS A VISUAL INSPIRATION FOR THE DRAWING.

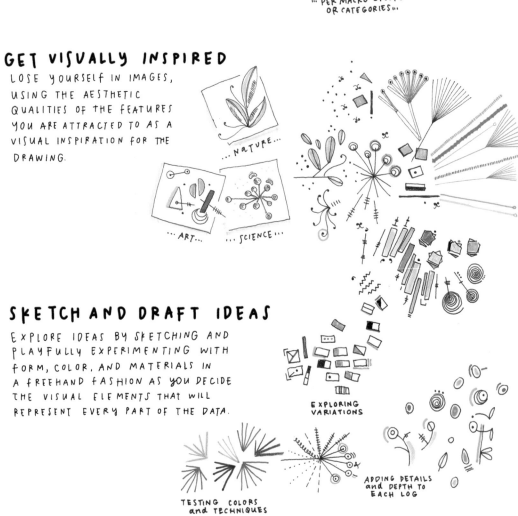

...NATURE...

...ART...

...SCIENCE...

SKETCH AND DRAFT IDEAS

EXPLORE IDEAS BY SKETCHING AND PLAYFULLY EXPERIMENTING WITH FORM, COLOR, AND MATERIALS IN A FREEHAND FASHION AS YOU DECIDE THE VISUAL ELEMENTS THAT WILL REPRESENT EVERY PART OF THE DATA.

EXPLORING VARIATIONS

TESTING COLORS and TECHNIQUES

ADDING DETAILS and DEPTH TO EACH LOG

DRAW THE FINAL PICTURE

After sketching and testing ideas for a data-drawing, you'll find an approach that works. Then create your drawing, ensuring it includes all the tiny details, trying to make it as beautiful (and as understandable) as you can.

DATA

SKETCHES AND DRAWING REFERENCES

COFFEE (OF COURSE)

JOURNAL

MATERIALS

DRAW THE LEGEND

Creating a legend starts with a question: "What does someone need to read my data-drawing?" In the legend, every design element that represents data is listed so the reader understands what everything means.

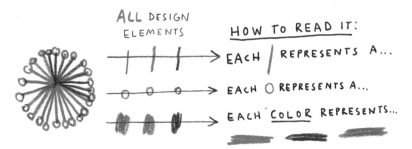

ALL DESIGN ELEMENTS

HOW TO READ IT:

EACH / REPRESENTS A...

EACH ○ REPRESENTS A...

EACH COLOR REPRESENTS...

AND THAT'S IT!
YOU'VE CREATED
A DATA-DRAWING!

#36 MY EXERCISE/ ACTIVITY ROUTINE

How active are you, and what type
of activity do you enjoy the most?
From walking to dancing, running for
buses, or cleaning the house, it all counts,
So make a record of your activity for
a week to find out!

#37 MY TO-DO LISTS

LIST-MAKING IS ALREADY A FORM OF VISUAL DIARY;
LET'S TAKE IT TO THE NEXT LEVEL.
FOR FIVE WORKING DAYS, START EACH DAY BY WRITING
A TO-DO LIST, AND DIVIDE IT INTO CATEGORIES
(WORK, STUDY, CHORES, THINGS I WANT TO DO...). AT THE
END OF THE DAY RULE OUT WHAT YOU DID, MARK THE
ITEMS YOU DECIDED TO DISCARD COMPLETELY, AND LEAVE
OPEN WHAT YOU WOULD MOVE TO THE NEXT DAY.
AT THE END OF THE 5 DAYS ANALYZE YOUR PAPER AND
MAKE A DATA DRAWING ABOUT YOUR WEEK.
(p.s. YOU CAN ALSO ADD ATTRIBUTES SUCH AS THE
LEVEL OF STRESS THAT THE TASK CAUSED, OR HOW
IMPORTANT OR DIFFICULT THE TASK WAS.)

#38 PHYSICAL CONTACT

How many people do you intentionally touch
over a day or week, and what does that
contact look like (hug, kiss, high five, etc)?
Which of this physical contact is romantic,
and which is more businesslike and formal
(such as a handshake)?

#39 SOCIAL MEDIA DETOX

FOR ONE DAY, LET'S GET OFFLINE. TRY TO RESIST
THE URGE TO CHECK SOCIAL MEDIA. EVERY HOUR
TRACK WHICH SOCIAL MEDIA YOU ACTUALLY CHECKED,
HOW MANY TIMES, AND HOW MANY TIMES YOU
WERE ABLE TO RESIST YOUR IMPULSE. BE HONEST
AND ADD NOTES ABOUT YOUR FEELINGS. WERE
THERE ANY POSITIVE OUTCOMES? HOPEFULLY!

#40 MY FAMILY

Map out and draw your family relationships,
whether you consider your family as blood
relatives, good friends, or much-loved pets!

#41 SMALL TALK

FOR ONE DAY, OR FOR ONE WEEK (TIMEFRAME OF
YOUR CHOICE), TRACK ALL OF YOUR VERBAL INTERACTIONS
(WITH STRANGERS, FRIENDS, FAMILY, COLLEAGUES...).
ANALYZE AND DRAW IF YOU ENJOYED THE CONVERSATION,
WHAT YOU TALKED ABOUT, AND HOW SIGNIFICANT YOUR
CONVERSATIONS WERE.

#42 MY HOLIDAY SOUVENIR

Draw a map of where you traveled, or
look at all the photos that you took while
on holiday, and categorize according to
their information to create a new way of
remembering your holiday for posterity!

#43 MY NEGATIVE THOUGHTS

FOR JUST ONE DAY, SET AN ALARM CLOCK FOR EVERY
WAKING HOUR, AND NOTICE IF YOU'VE HAD NEGATIVE
THOUGHTS IN THE PAST 60 MINUTES. HAVE YOU BEEN
FRUSTRATED? ANXIOUS? WORRIED? WAS IT ABOUT
SOMETHING SPECIFIC, OR JUST GENERAL DISCOMFORT?
WHAT COULD YOU DO ABOUT IT? MAKE YOUR DATA
DRAWING, AND HOPEFULLY BECOME LESS BOTHERED
BY YOUR NEGATIVE THOUGHTS OVER TIME.

#44 MY MUSIC COLLECTION

Is your music collection physical or digital?
How much of it do you actually listen to these days?
Are certain artists from your past slightly
embarrassing? Choose how to define your music
collection (all the physical and digital music
you own, or all the playlists you have created
on a music-streaming platform over a certain
amount of time) and begin to count, categorize,
and draw.

#45 PROCRASTINATION

FOR FIVE WORKDAYS, ACKNOWLEDGE AND DRAW EVERY
TIME YOU PROCRASTINATE. WHAT TIME OF THE DAY IS IT?
WHAT IS THE TASK YOU ARE DRAGGING AROUND WITH YOU?
HOW LONG DID YOU PROCRASTINATE FOR? DID YOU DO
IT IN THE END? DRAW A SPECIAL MARK IF THIS EXERCISE
OF NOTICING WAS HELPFUL TO GET THE JOB DONE.

#46 THE ANIMALS I SEE

What animals (besides your pets) do you notice in your environment? For a day (or week) imagine you are on safari in your own neighborhood, collecting and drawing the different animals you spot.

#47 PRESSURE VERSUS WILL

IN ONE DAY, TRACK THE THINGS YOU DID, THE THINGS YOU
FELT PRESSURED TO DO, AND THE THINGS YOU WANTED TO DO.
WHAT DOES IT TEACH ABOUT YOURSELF? WHAT DETAILS
CAN YOU ADD TO CONTEXTUALIZE THESE ACTIONS?
MAKE A DATA DRAWING OF THEM.

Dear Data is the story of how we, Giorgia and Stefanie, became friends by revealing to each other the details of our daily lives. Each week, for one year, we used our personal data to get to know each other.

Every Monday we would choose a particular subject to observe and count for the whole week: how often we complained or felt envious; when we came into physical contact and with whom; the sounds we heard around us. At the end of the week we would draw this information on a postcard that we would drop into an English post box (Stefanie) or an American mail box (Giorgia).

Since the project was made public we have seen hundreds of postcards made by people who, after hearing our story, wanted to try the process for themselves, many seeking out their own data "penpals" and also setting their own yearly challenges to draw their data.

We are excited by the public response to Dear Data, and the acquisition of the 104 postcards and accompanying sketchbooks by the Museum of Modern Art (New York) for their permanent collection has validated our belief that we can use what we so coldly call <u>data</u> to get more in tune with ourselves and others.

THIS IS WHY WE CREATED THIS JOURNAL FOR YOU

Learn about the award-winning Dear Data project in our 300-page illustrated book:

Begin a data-drawing correspondence with a penpal of your own using the Dear Data Postcard Kit:

ISBN: 978-1-61689-532-7

ISBN: 978-1-61689-632-4

GIORGIA LUPI IS AN INFORMATION DESIGNER AND ARTIST. SHE USES DATA AS HER TOOL TO BETTER UNDERSTAND OUR HUMAN NATURE, AND DATA VISUALIZATION AS HER MEANS OF EXPRESSION. SHE CO-FOUNDED ACCURAT, A DATA-DRIVEN DESIGN FIRM WITH OFFICES IN MILAN AND NEW YORK, WHERE SHE IS THE CREATIVE DIRECTOR. AFTER RECEIVING HER MASTER'S IN ARCHITECTURE, SHE EARNED A PhD IN DESIGN AT POLITECNICO DI MILANO. HER TED TALK ON DATA HUMANISM HAS OVER ONE MILLION VIEWS.

www.giorgialupi.com

STEFANIE POSAVEC is a designer and artist whose work focuses on non-traditional representations of data derived from language, literature, or scientific topics. Often using a hand-crafted approach, her work has been exhibited at, among others, MoMA in New York, CCBB in Rio de Janeiro, the Science Gallery in Dublin, and the V+A in London. In 2013 she was Facebook's first data-artist-in-residence at their Menlo Park campus.

www.stefanieposavec.com